BOATYARD DOGS

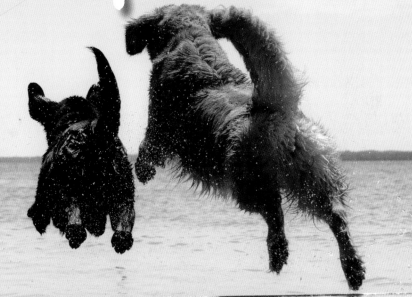

Published with **MAINE BOATS, HOMES & HARBORS** Magazine

Introduction by John K. Hanson Jr.

Down East Books

Camden, Maine | Guilford, Connecticut

In partnership with Maine Boats, Homes & Harbors, Inc.
Published by Down East Books
Down East Books is an imprint of Globe Pequot
Trade division of The Rowman & Littlefield Publishing Group, Inc.
4501 Forbes Boulevard, Suite 200, Lanham, Maryland 20706
www.rowman.com

Unit A, Whitacre Mews, 26-34 Stannary Street, London SE11 4AB

Maine Boats, Homes & Harbors magazine comes out six times a year (2017 marks our 30th year) and we feature dogs (and other pets) in every issue. For more information, or to subscribe, you can find us online at Maineboats.com.

Boatyard Dog™ is a registered trademark of Maine Boats & Harbors Publications, Inc.

British Library Cataloguing in Publication Information available

Library of Congress Cataloging-in-Publication Data available

ISBN 978-1-60893-501-7 (hardback)
ISBN 978-1-60893-502-4 (e-book)

∞™ The paper used in this publication meets the minimum requirements of American National Standard for Information Sciences—Permanence of Paper for Printed Library Materials, ANSI/NISO Z39.48-1992.

Printed in the United States of America

CONTENTS

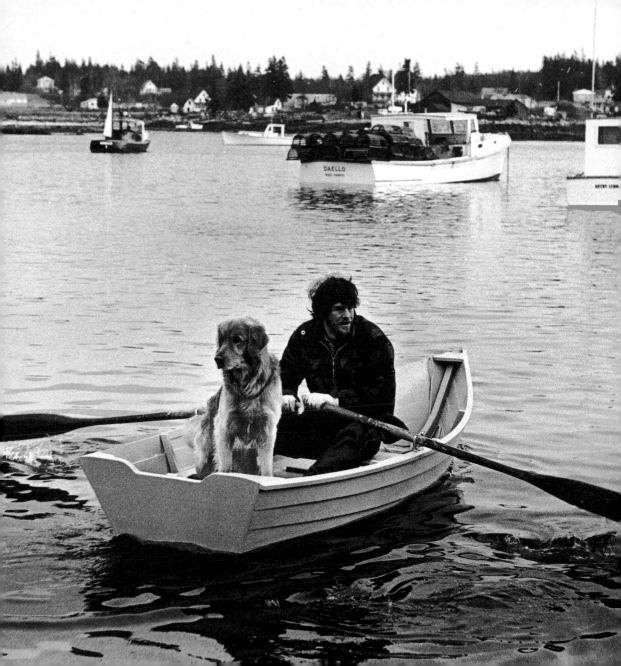

INTRODUCTION

All dogs can be wonderful, but not all dogs can be Boatyard Dogs. It takes a certain type of character and a certain wetness, to earn the title. Take my old golden retriever, Fagin. He was *Maine Boats, Homes & Harbors'* first "Boatyard Dog," but by no means was he the first of his type. I have a lovely old photograph from the early 1900s of a Friendship sloop sailing downwind. Standing proudly on the aft deck is a small pug with his snout pointed directly into the wind, positioned to smell any wind shifts before anyone else on the crew. That dog was a proud member of the Boatyard Dog club—wide stance, alert and ready for anything.

Dogs aren't born into the Boatyard Dog club, rather they must earn their membership. Fagin got his stripes early. He was just a puppy when he came with me to work at the Henry R. Hinckley Company in Southwest Harbor, Maine. On his first trip aboard the workboat *Roustabout*, he jumped after me as I was boarding a yacht to drop off some keys. He missed, landing in the water instead of on the deck. Clinging to the top of the rudder when I got to him, he yowled loudly as I dragged him back

Opposite: John K. Hanson Jr. and his dog Fagin in 1975

aboard *Roustabout*. He never jumped from workboat to yacht again. But first thing in the morning for the rest of his time at Hinckley, he would yowl until he was back aboard *Roustabout*.

A good Boatyard Dog needs more than good sea legs to make it in this business; he or she also needs extraordinary people skills. A good BYD can handle customers, staff, and management. Fagin was a great example. Yacht owners visiting Hinckley would admire and pet Mr. F, as would craftspeople working at the yard as the time clock clicked away. All the parties were happy.

When I started *Maine Boats, Homes & Harbors* magazine in the summer of 1987, one of my greatest fears was having to write the regular publisher's note in the front of the magazine. I had to find enough words to fill two thirds of a page without sounding vain or pompous. While mulling this over, I glimpsed a picture of Fagin on my desk. He was an old man by then, but still active. The idea came to me all of a sudden—why not write a short note about him as a Boatyard Dog. His photo and write-up filled half the space allotted to my note, and made filling the rest much easier. It is hard to be pompous when sharing space with a dog; silly, certainly, but pompous, no.

That may have been the most inspired thing I did with the launch of *Maine Boats, Homes & Harbors*. Thirty years have gone by and more than 100 dogs (plus a few cats and even a chicken) have graced our pages. They all have set a tone for the magazine, and taught me, and the rest of the staff, not to take ourselves too seriously. Remember that the next time a wet dog jumps into your dinghy or onto your lap.

The following columns are reprinted from *Maine Boats, Homes & Harbors* magazine. In some instances boatyards have changed hands, and, sadly, many of the dogs profiled have moved on to the great boatyard in the sky. We decided not to include those updates, because in our minds, and on these pages, all dogs (and other animals who wish they were dogs) are immortal.

—John K. Hanson Jr.
Publisher, *Maine Boats, Homes & Harbors*

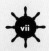

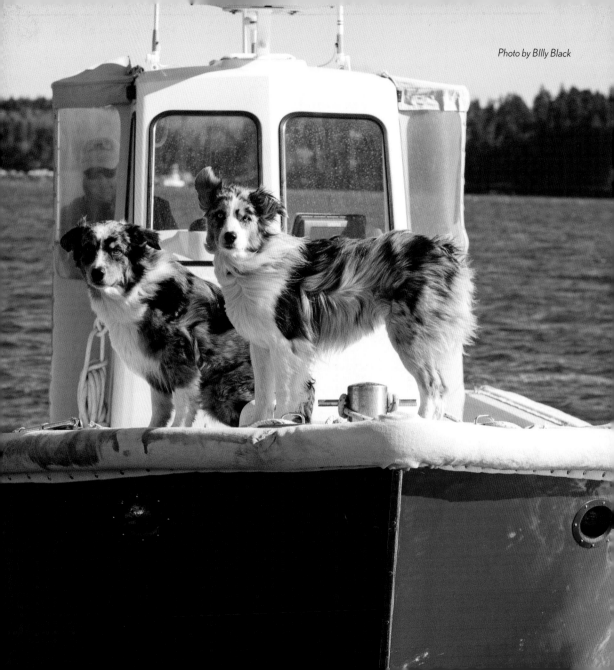

DOGS AT WORK

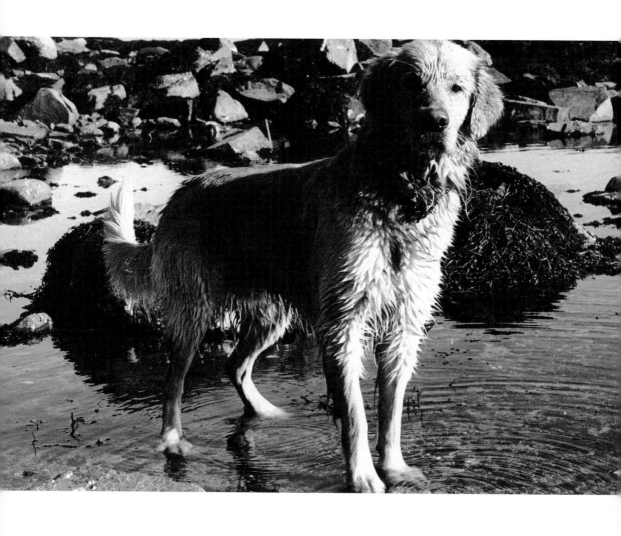

FAGIN — the dog who started it all

Hi, I'm Fagin. I've worked at some of the finest establishments on the coast. While at Hinckley's, I used to ride with Henry on his golf cart. I was there when Jon Wilson was just digging out, in the beginning of *WoodenBoat Magazine*. Now I'm here at this rag, *Maine Boats, Homes & Harbors*, supervising. I want to see photos of fellow top dogs—dogs in management positions, the real powers behind the Maine boat business. (Fall 1987)

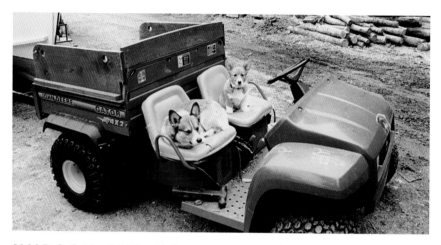

HUDSON AND HANNAH – working too hard to smile

There's no waiting for the tide at the local saloon for Hudson (left) and Hannah (at the wheel), when it comes to boat-launching time. They have taken charge of the launch vehicle and won't be giving it up until the latest Hampton boat, built by Dick Pulsifer of Brunswick, is safely in the water. A couple of corgis, they take their position of responsibility so seriously that they won't even crack a smile for the camera. (June–July 2003)

MELLI – eclectic

Melli, trustee of the tool room at Brooks Boats on Mt. Desert Island, takes a break from the shop to assist Leigh Brooks with her footwork. Leigh, daughter of John Brooks and Ruth Ann Hill, has the standard one-foot-in-front-of-the-other down cold, but it's the hop, skip, and jump that need attention. Melli provides the handhold for that.

Melli is what's known as a mixed breed. While there are some—especially those with pedi-greed companions—who see that as a pejorative term, we should point out that mixed dogs gener-ally are a combination of the best characteristics of the purebred. In Melli, for example, we see the loyalty of the German shepherd, the color of the black Lab, the coiffure of the Newfie, the strength of the malamute, the bravery of the St. Bernard, and the pure joy of the golden retriever. Seems like the ideal boatyard dog to us.

Come to think of it, mixed breed does sound pejorative. Let's call Melli eclectic and pin a medal on her chest for being so gentle with Leigh. (Fall 2003)

ROCKY – optimistic

Although Rocky's heart belongs to Dody LeClair, shipwright at the Royal River Boat Yard in Yarmouth, Maine, the owners of the yard, Allan and Bob Dugas, say he really should be called Royal River Rocky, because he is a faithful companion to everyone in the yard—friend of their children, the employees and, of course, the customers.

Rocky, a basset-Lab mix, shows you around if you're new to the yard, and escorts you to your boat if you're a regular. He supervises engine trials and test runs, and keeps track of coffee and lunch breaks, and quitting times. Yes, he guards against squirrels. But, no, he doesn't mess with skunks or porcupines—he lost a couple of encounters with them early in his career and would just as soon avoid any others.

Are times tough? Are you feeling down? Stop by the Royal River Boat Yard, and hardworking, optimistic Rocky will soon have you feeling that everything is going to be ok. (February–March 2004)

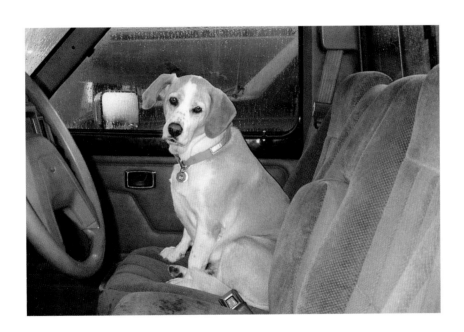

DECATUR – he knows his canvas

If you hang around the Rockland waterfront long enough, you'll run across Decatur, who hangs around there, too. Actually, "hangs around" is too passive a term for a boatyard dog like Decatur. The truth is he works on the waterfront, helping his pal John LeMole of Gemini Marine Canvas sew sail covers, dodgers, boat covers, and the like, and inspecting the work after it's finished.

Short of DNA analysis, we'll never know Decatur's true origins, but after visual inspection we can surmise: rippling

muscles and a sturdy body point to Labrador retriever; a sporting gentleman's demeanor suggests wolfhound. But what, after all, does breeding matter? What's really important is that Decatur knows his canvas—he knows his warps and his wefts, and he has an uncanny ability to spot an unprotected unselvaged edge at forty yards. All of which is essential to a small company that bases its success on the quality of its work. (April–May 2004)

DOUG – the tug pug

This tough little deckhand, whose size belies his power, can be found working with the all-volunteer crew of the National Historic Landmark Tugboat *Luna* in Boston, Massachusetts. The *Luna* is the last full-size wooden tugboat on the Atlantic and Gulf coasts as well as the world's first diesel-electric tug built for commercial ship docking service.

Doug is bluff bowed (or is it bow-wowed?) and full bodied, and has a rounded pilothouse. He has been known to push around dogs much larger than himself and to tow his housemate Betty Brummitt, who is twice his size, across the deck while she hangs on to her tail (hawser?). No job is too tough for this strong, steady, and compact marine canine.

Doug oversaw and was very pleased with the work done during the historically accurate hull restoration at Sample's Shipyard (now Boothbay Harbor Shipyard) in Boothbay Harbor and is of the opinion that Maine craftsmen are the best. (April–May 2006)

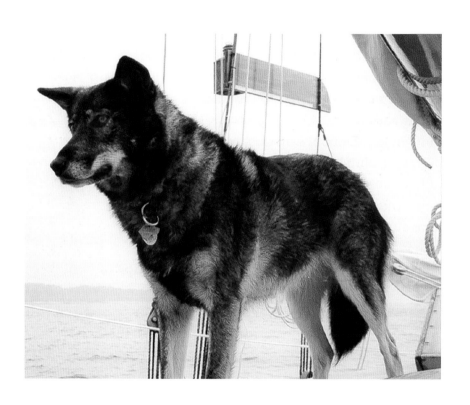

SAXON – constant companion

She might not look like much of a self-starter, but Saxon is a regular dynamo. Constant companion of Ted Walsh of Conway, New Hampshire, she has personally overseen the construction of a 24' pulling boat for use on the Upper Missouri River, the building of two Aleutian sea kayaks and one Greenland sea kayak, and the renovation of *Black Star,* cruising the coast from Kittery, Maine, to the Bay of Fundy in New Brunswick. In the winter she is just as busy, dividing her time between the boat shop at Stonehearth Open Learning Opportunities in Conway, New Hampshire, and her office job at TMC Books, also in Conway. She is also the main character in a children's book about sailing—*Merlin and the Black Star*—so she also has book signings to work into her already chaotic schedule. (April–May 2005)

S K Y – hooked on decaf

Sky is the most interesting dog. Originally from a pound in Miami, Florida, she is now a resident of Flying Cat Farm (go figure) in Friendship, Maine.

As gregarious a critter as ever came down the pike, she is welcomed in the local hardware stores, boatyards, boat shops, and the like, where she starts off her day in a coffee klatch, with the Real Men, nodding her head over the weather prognostication and rolling over and kicking her feet in the air in response to the off-color jokes. Her favorite concoction is decaf; her brand is Green Mountain.

A genuine sprouting dog, she adheres to the old post office rule: neither rain, nor snow, not sleet, nor hail will keep her out of her kayak. Here she is doing the downhill toodleloo with you know who, her constant companion yacht broker Gerry Hull.

(February–March 2006)

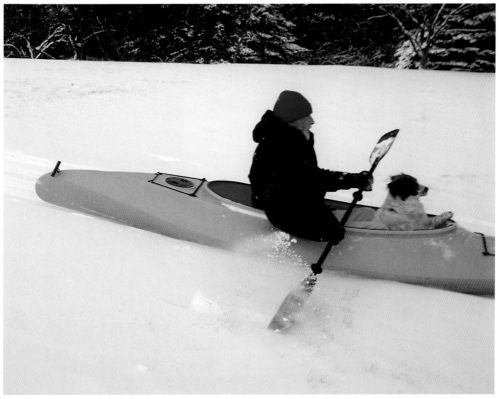

Photo by Karen Hull

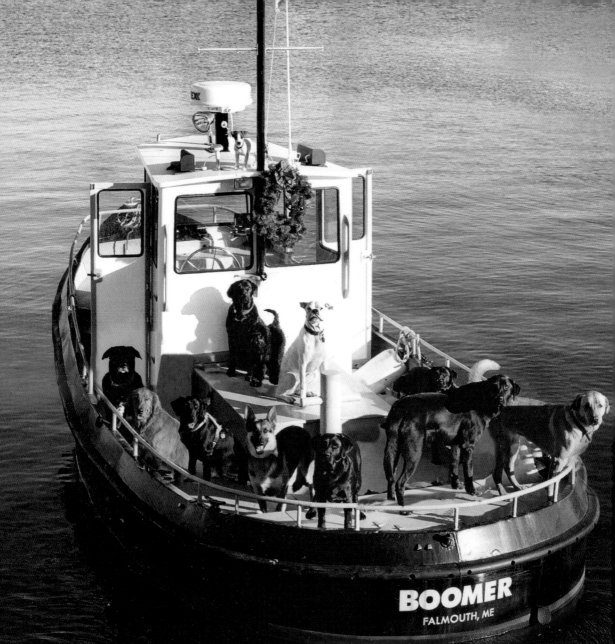

BOOMER
FALMOUTH, ME

HANDY BOAT'S CROWD

A lot of people studied this photograph for a long time. "Is it really possible," someone asked, "that so many dogs could stand so still and all look at the camera at the same time?" "Dunno," someone else said. Then the publisher said, "Send it out for digital analysis before we're accused of slipshod journalism." So we did. The report? A Cray X1E supergonkulator with 8 vector pipes per MSP and 18 gigaflops theoretical peak performance determined that there is a 99.9% probability that it is as real as we wish it were.

According to head dog-herder Merle Hallett, this crowd—there's no other word for it—assists the crew every day at Handy Boat in Falmouth, Maine. (August–September 2006)

Photo by Liz Donnelly/Maine Photo Co.

BETTY – the belle of Spruce Head

Here's Betty at Spruce Head Marine. She's checking out the talent while her pal, Peter Spectre, paints the bottom of her boat, a Hampton launch built by Dick Pulsifer. Passing by, out of the camera's view, is Studley the black Lab.

Eibhlín

Betty, a Shih-Tzu, goes into her pose. Back straight, derriere up, chest out, tail artfully curled, hair falling like a veil over her eyes, face a dark pool of mystery—a blonde, but more than a blonde: layers of yellow, gold, and tan. Women spend hundreds of dollars in the beauty parlor looking for that look.

"Hi there, Big Boy," Betty says, fluttering her lashes. "Why don't you stop and nuzzle for a while?"

You'd think that Studley would take her up on an offer like that, but no, he pauses, he looks Betty up and down, he says to himself, "Humph, fuzzball brand looking for commitment," and then he rambles on in the direction of the boat shop.

Betty, ever confident, watches him recede into the distance. He'll come back, she knows. They always do. (August–September 2006)

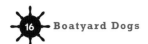

TIM AND BOATSWAIN – a pair of hobbyists

Let's hear it for Tim and Boatswain, two alleged employees at Artisan Boatworks in Rockport, Maine. You'd think that with such alert demeanors they would be heavily involved in operations, but no, they've left all that to the two legged working stiffs on the staff. They're not stupid, don't cha know. According to owner Alec Brainerd, a member of the two-legged crowd, both gents are too busy with their hobbies to be bothered with planking and fastening, fairing, caulking, or painting.

Tim (left), a two-year-old Walker hound, keeps himself busy with barking and running away. When not tethered to his run he can usually be found in the garbage out back or over at the pound playing pinochle with the poodles.

Boatswain (right), a five-year-old Labrador retriever, is more mature. He generally stays close to the shop, where he can usually be found in a pile of shavings, happily chewing on the very boatbuilding pattern the inboard joiners need at that moment. His principal outside interests, as you would expect given his lineage, are fetching and quantum physics. (April–May 2007)

HALLEY — retriever, herder, perfect

There are mixed breeds, and then there are superior mixed breeds. Halston Thorkleson—a.k.a. Halley—an employee at a yard in Brooklin, Maine, is a representative of the latter. Here we have at once a yellow Lab and a border collie. Retriever and herder. Perfect.

"Hey, Halley," one of the yard crew says, "fetch me a quarter-inch shoulder eye bolt two inches long." And she does.

"Hey, Halley," the yard manager says, "the gang over in the east yard have gone shiftless. Drive 'em back to work." And she does.

Of course, that only happens when Halley's on duty. During the summer season, she's napping in the warm sun on the dock, or swimming in the cold clear water, or playing chicken with the minks that hang out along the waterfront. When her chums take a day off, she goes "skiffin" with them in the little boat (a blast) or sailing with them in the big boat (boring).

When you're a representative of a superior mixed breed in a boatyard on the coast of Maine, life is good. (August–September 2007)

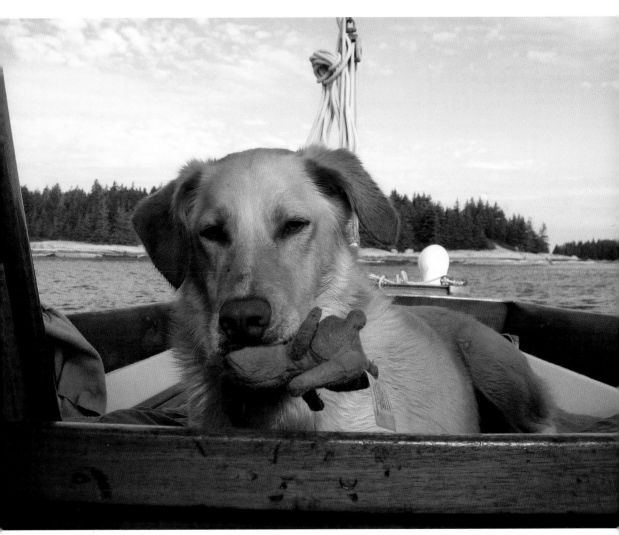

Photo by Virginia Campbell

GLACIER

Here's Glacier, waiting for his pal, Ava Brown, daughter of the owner of West Bay Boats of Steuben. The shop had just launched a new boat, and Ava was aboard at the mooring,

cleaning up and taking photographs. Glacier—an appropriate name for an all-white shepherd, is it not?—was left behind on the beach to stand watch, which he did by staking out a position on a low-tide ledge. There he sat, unaware of the rising tide, his only concern being to be as close to Ava as possible while guarding the shore against—what?—footpads? out-of-town clam-diggers? marauding pirates?

"Silly boy," Ava said.

"Silly?" Glacier thought. "So she wants to face Blackbeard all by herself?"

Meanwhile, the tide kept on rising until Glacier was surrounded by water. That was when Ava discovered that she had a

rarity: a boatyard dog who didn't like to swim. Glacier would have to be rescued by rowboat.

Glacier may be a chicken when it comes to the water (he entered the world-famous Boatyard Dog Trials in 2003 with his girlfriend Wynter, another shepherd, and refused to get his toes wet then, too), but he's a tough old buzzard nevertheless. Last August he went into the hospital for major surgery and within just a few days he was back in the boatyard, keeping the piratical swine at bay.

"Glacier has touched the hearts of many with his love and loyalty," Ava Brown said. "Mine most of all." (March 2008)

MAX AND CHOLO – on a busman's holiday

Every once in a while the hands at the Smith Boatyard in Brunswick, Maine, take a busman's holiday and get out on the water for a little fun and frolic. Here they are in the yard's work-boat *Close Enough* off Whaleboat Island in Casco Bay. The two canine gents at the bow are Max (starboard) and Cholo (port).

Retrievers, they're poised to fetch whatever they see, whether the Smiths want it fetched or not.

"Max and Cholo are our first alert in spotting ducks and, especially, seals," said Dana Smith, "but they often need to be restrained from leaping overboard to play with their aquatic (and somewhat reluctant) friends." (Summer 2008)

R O C K Y – likes to stay dry

It's a beautiful evening on the coast of Maine, and what better time to make nice in a rowboat? That's Hannah Mendlowitz at the oars and Rocky, a mixed breed— in other words, a veritable treasury of dog types—gazing blissfully up at her with liquid eyes.

Photo by Benjamin Mendlowitz

"Rocky may not be an official Boatyard Dog," said professional photographer Benjamin Mendlowitz, who took this picture, "but he is a yard dog and somewhat of a boat dog. He prefers flat calm rows or motorboat rides; not much for sailing when the wind's up. He hates getting wet. The one time he missed the leap from boat to float, he disappeared. Just as panic was setting in I found him—he was under the float, high but not so dry on top of a cross-beam. Rocky's favorite maritime activity is a visit to a schooner at dinnertime while out for an evening shoot with me." (March 2009)

ROCKY (AGAIN) – photographer's assistant

We can see here that Rocky is driving the boat, which makes sense because Rocky is Benjamin Mendlowitz's assistant and someone has to do the driving while Mendlowitz, an acclaimed marine photographer, is working the camera.

Rocky certainly has the tools for the job: GPS to tell him where he is going, dials to report how the engine is doing, a throttle to speed him along, and not one but two suicide knobs on the wheel for lively directional control. This is all well and

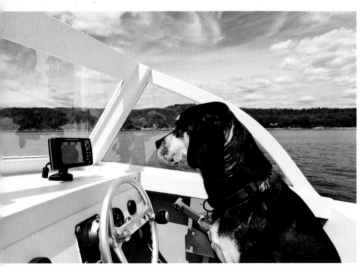

good, but it's clear that Rocky doesn't have his paws on the wheel. With no evidence to the contrary, we suspect that he is texting . . . er . . . make that Rexting . . . while driving! To which we say, WoofTH?! (May 2012)

Photo by Benjamin Mendlowitz

HARLEY AND DYLAN – water dogs

This lucky pair of water dogs is bound for Ireland.

Harley (short for Harlequin), a long-haired dachshund, sails with his mate Dylan (short for Dillingford) out of Florida in the winter and Maine in the summer. Both are water dogs, though their companions, the Mulcahys, didn't know that when they first adopted them.

"We run a sailing school here in Maine and in Florida," wrote Maura Mulcahy. "Harley and Dylan were put up for adoption, and our first introduction to them was on our O'Day 25 on Sebago Lake. You see, we wanted to be sure they were 'boat dogs' before we made the commitment to adopt them. They have worked out like champions. They go absolutely insane when they hear dolphins—they hear them before we spot them! We have enjoyed thousands of hours sailing with our buddies. We hope to take them to Ireland on our next trip over for our fifteenth anniversary." (Summer 2009)

YIP AND YAP – and how about those chickens?

Here we have a pair of Pembroke Welsh corgis, originally bred for herding. That's an occupation that seems unusual for boatyard dogs, but consider all they are called on to do in Dick

Pulsifer's Brunswick boat shop: There are boatbuilder Pulsifer himself and his assistant to keep in line, visitors to protect from all those sharp tools, and a bunch of chickens to keep out from underfoot. (Boatyard Chickens? What's next? Boatyard Bunnies?)

Big in body, short in leg, corgis make wonderful pets and—believe it or not—spectacular guard dogs. Yip and Yap might spend a lot of time sleeping in the shavings—Pulsifer builds wooden Hampton boats— but if anything untoward should happen, they are right on top of the job. They might be short, but given provocation they have what's best described as attitude. Nobody even thinks about messing with the Pulsifer boat shop when they're around. (June–July 2010)

Photos by Jamie Bloomquist

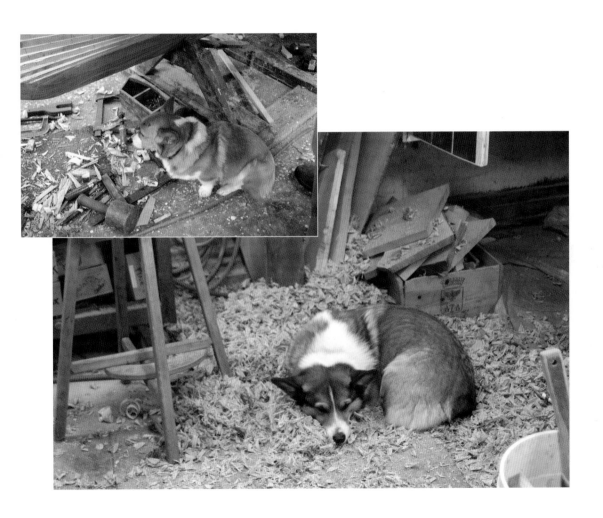

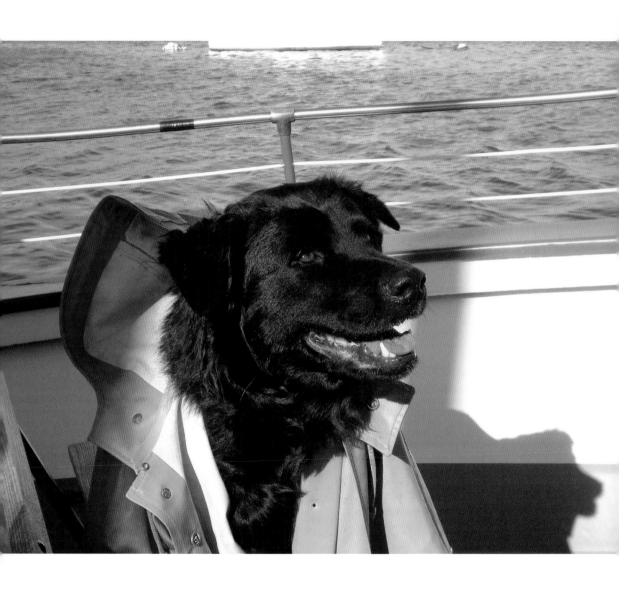

JETHRO – mail dog

Five years old, of Labrador/Chow lineage, Jethro was found roaming the streets of Louisiana shortly after Hurricane Katrina and was rescued by kind-hearted souls. Now living with Bennett and Cayce Gray of Deer Isle, he works on *Miss Lizzie* and *The Mink*, two mail boats that make the run back and forth between Stonington and Isle au Haut.

Jethro assists his pal Bennett with boarding passengers and stowing their luggage. He stands watch by the helm while they are underway. He helps deliver the mail on Isle au Haut. And, by request or not, he provides guided tours of both islands—Deer, and Isle au Haut.

"Jethro goes on the boat every day with Bennett and is a huge hit," writes Cayce Gray. "People are amazed by how well behaved he is and cannot believe it when they see him climb the steep ladder from the lower deck to the upper deck on the *Miss Lizzie*. Residents of the island know him well, and tourists stop to take pictures of him."

And why not? After all, Jethro is one handsome seagoing dog.

(Summer 2010)

WINSLOW – flotsam chaser

Heaven help us, here's Winslow, the first boatyard dog to come to us via Facebook. He's on a busman's holiday from his full-time position at the Tisbury Wharf Marina on Martha's Vineyard. Nine-to-five (and sometimes way into the night) he goes after the flotsam, jetsam, and lagan in the harbor. On occasion he acts as guard dog when kids are swimming from the S/V *Shenandoah*, circling the sailing vessel until they are all safely back on board.

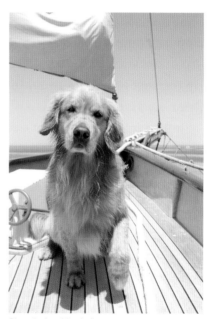

And when required he serves as the local ambassador to visiting yachts, a function he fulfills pro bono, though he is not averse to accepting a tip. Today he's the foredeck dog on a boat cruising Vineyard Sound. As soon as the camera session is over he'll be seeing to that baggy jib. (March 2012)

Photo by Lisa Vanderhoop

COLBY – the captain of industry

Technically, Colby, a Labrador retriever, is not a boatyard dog. Rather, she's a businesswoman, serving faithfully as the schooner *Mary Day*'s office dog. Colby works alongside Captain Jennifer Martin, who is co-owner (with her husband Captain Barry King) of the *Mary Day* and manager of shoreside operations.

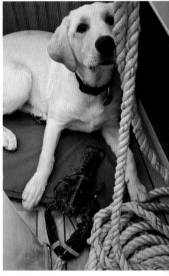

At least twice a year—at the beginning and end of each season—and once in a while in between, Captain Martin joins a cruise aboard the schooner. That's when Colby the office drudge enters a closet (telephone booths being obsolete), rips off her power suit, and emerges as Colby the Schoonerdog, Captain Martin's executive officer and pal to the entire crew.

Photo by Jim Dugan

No doubt there are those who might wonder about the proper . . . er . . . um . . . facility for a schoonerdog at sea. While some wags have suggested that there has always been a real location, hence the origin of the name poop deck, we must point out that Colby, being as decorous at sea as she is in the office, would not think of using it; she always waits patiently to take the ship's boat ashore. (Summer 2012)

HUGO – working-class hero at Belmont Boatworks

If you were a big dog full of lots of slobbery energy, where would you rather work? Around the house or in a boatyard? Hugo, a St. Bernard of herculean proportions, knew from the start that he wanted the latter, so when he found himself left at home when his pal Dan Miller went off to work at the Dark Harbor Boat Yard on 700 Acre Island, off Islesboro, he hatched a plan. He decided to cause just enough trouble to get evicted from the house, but not so much that he ended up back at the pound.

It almost didn't work. The first trip to Dark Harbor aboard the crew boat from the mainland did not go well—something about a seasick St. Bernard who had been eating rotten bait seemed to turn off his fellow commuters. Still, Hugo knew after his first day on the job that on the job was where he had to be. Currently a founding partner at Belmont Boatworks, a full-service yard west of Belfast, he is beginning to slow down, but he is heartbroken if anyone tries to patronize him. That's the Boatyard Dog Way: They look out for their family and their crew, not the other way around. (Summer 2013)

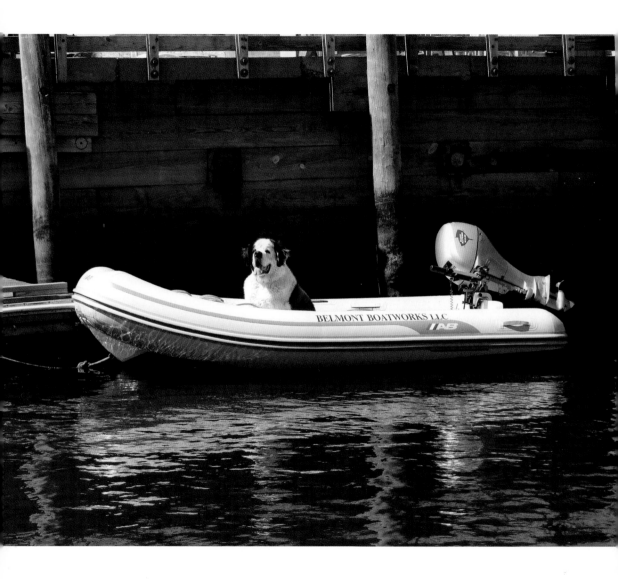

SCUPPER AND PERRY – sailor dogs

Anyone who knows the schooner *Appledore* knows Scupper, left, and her friend, Perry. The labradoodles crew on the 60-foot, Camden-based schooner, which is owned by Robin McIntosh and Rick Bates. Scupper has been sailing on *Appledore* since she was a puppy. Perry was a rescue from an Ohio puppy mill. They both love to pose for photographers. Once, when Gov. Paul LePage visited Camden Harbor, he walked down the dock past Scupper, who was posing for him on deck. When LePage did not stop (is he a cat person?), Scupper barked sharply to get his attention. The governor came back to pay his proper respects and the resulting photo made the front page of the local newspaper. Any day now, Scupper might run for office. (April–May 2014)

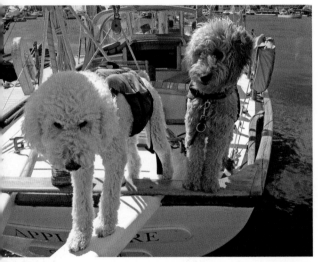

Photo by Jane Kurko

BRIGANTINE – unabashed boat enthusiast

Brigantine, known as "Briggs" by her owners, Ryan and Michelle Raber, is an Irish water spaniel who loves being on (and in) the water. So much does she love sailing that during outings to the family's C&C 34 *Scapa* at the Portland (Maine) Yacht Club, Briggs often launches herself into the water when she tires of waiting for a ride out to the boat. Needless to say, this prompts frantic rescue adventures.

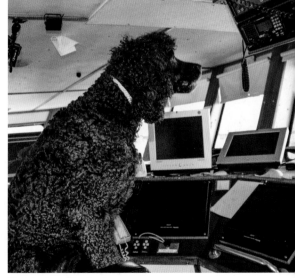

Ryan is captain of the mid-water herring trawler F/V *Providian*, which he owns with his father, Walter. Briggs loves going aboard *Providian* too, being as amenable to a day of hard work as she is to an afternoon of sailing. She is shown here in the 113-foot-long working vessel's wheelhouse. Is she right at home? Yes. Is she in command? Most certainly. (June–July 2013)

Photo by Anne Blanchard

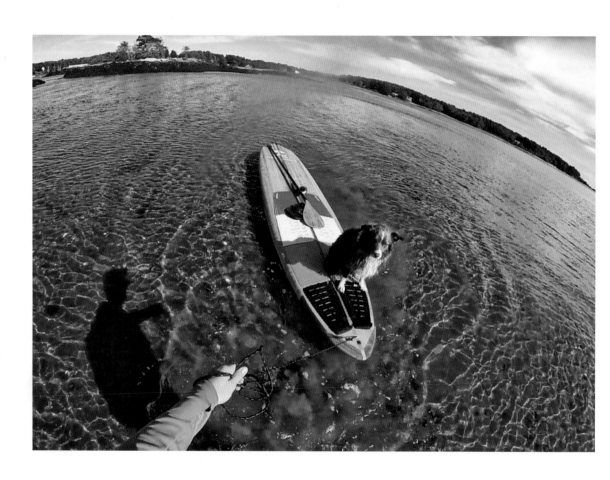

LAYNIE – herder, helper, paddleboarder

Ever since she was a pup, Laynie has provided company and inspiration to her human "pet" Kyle Schaefer. In fine Australian shepherd style, she has herded him through many endeavors. Most recently, they have collaborated on a relatively new project: building wooden stand-up paddleboards in Eliot, Maine, under the name Tidal Roots. It is not uncommon to find Laynie covered in wood shavings after a day spent paw-shaping boards in the shop. She helps with the cleanup as well, by chewing on . . . er . . . breaking down any wood scraps that fall her way.

While she loves her work, Laynie is always quick to hop aboard for a quick R&R session while Kyle paddles his board in pursuit of striped bass with his fly rod. She has great balance, which helps in her role as head fish herder. She also has figured out how to let Kyle know what she wants: bark once to go fishing, twice to paddle around, and three times to chase those pesky seagulls. (Summer 2014)

SIERRA – ready to lend a paw

Sierra was a stay-at-home dog until she joined the team at Cape Cod Shipbuilding Company in Wareham, Massachusetts. An 11-year-old yellow Lab, Sierra keeps close tabs on her companion, company President Gordon Goodwin, and is ready to lend a paw for any boatyard task. Here she is on a test sail of Cape Cod's new Marlin Heritage 23. (February–March 2015)

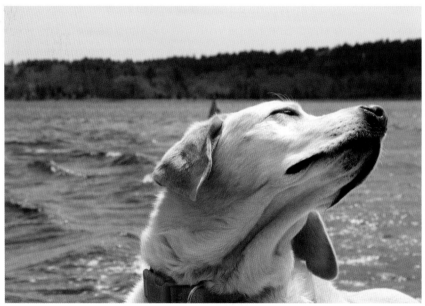

Photo by Michael Magni

OLIVE – launch helper

Olive is the official greeter for the Camden Yacht Club, where her owner Barb Goos is dockmaster. Olive, a 10-year-old yellow Lab, was supposed to be a seeing-eye dog. Goos, who volunteers as a puppy raiser for Guiding Eyes for the Blind, spent a year socializing Olive and teaching her obedience. But when she took her entrance exam, Olive did not have the right qualities to continue guide training. "She chose another career. She chose to be the ambassador for the yacht club," said Goos. What a choice: do a serious job or have fun around boats. Good call, Olive.

(April–May 2015)

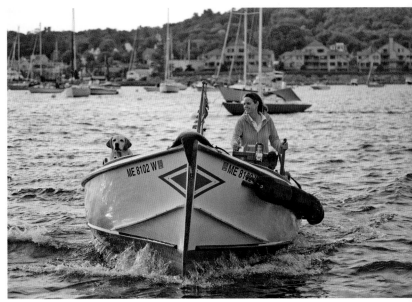

Photo by Alison Langley

CARTER – marketing dog

Carter, a perfect blend of various unknown breeds, is a rescue dog who arrived in Maine after spending the first year of his life in Tennessee. It took this former flatlander a few heart-to-heart conversations and a lot of turkey to realize that he's actually into boating.

While Carter has found his sea legs, his preferred activities include taking his owners, Audrey Hodgdon and her fiancé Caleb Easton, for long walks on the Boothbay Region Land Trust trails and (unsuccessfully) attempting to befriend porcupines. During the week, Carter is the official marketing dog for Hodgdon Yachts in East Boothbay, where Audrey, the daughter of Tim and Cathy Hodgdon, works as marketing manager and Caleb works in the service department. Audrey is the sixth generation of Hodgdons to work at the family-owned yard, which recently celebrated its 200th anniversary in business.

(Summer 2015)

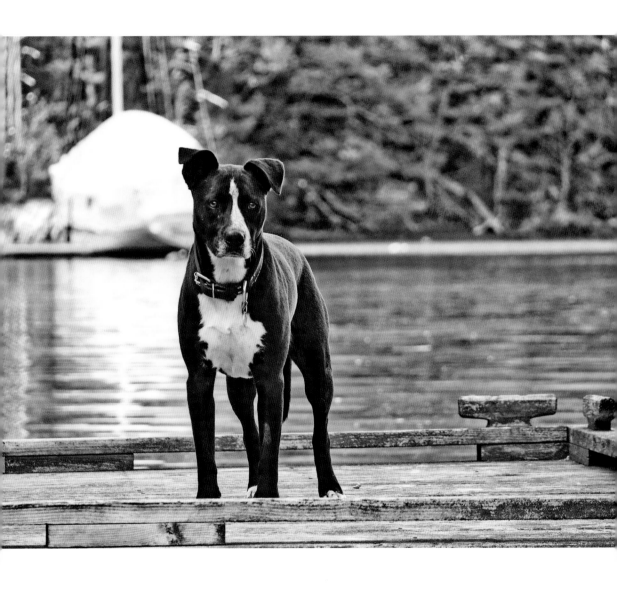

MAYA AND THE EDGE – hardworking

Maya and The Edge are the resident boatyard dogs at Redfern Boat and Up Harbor Marine in Bass Harbor, Maine. Maya, a Bernese Mountain dog, and The Edge, a Newfoundland, are inseparable. They take their work to heart, monitoring the tasks of their boatyard humans, Carlton Johnson and Kathryn Walsh, at all times.

As pups they were especially gifted at facilitating the disappearance of any inventory small enough to be hefted in their substantial mouths. Something missing? That badger brush you just put down? A foam polishing pad or an impeller? Rigorous surveillance ultimately revealed the culprits and the location of their stash, which included roller covers, tape, Volvo parts, hose clamps, fragments of Soundown, a small life vest, rope, and, atop the pile, a captain's cap.

The dogs' humans report that thanks to subsequent positive reinforcement training, the duo completed their one-year probation without relapse. They have paid their restitution in the form of wags and kisses and assumed their duties as delivery mates and general supervisors of boatyard activities, especially social networking. They are quite proficient at that, albeit a little slobbery. (January–February 2016)

WILSON – learning the ropes

Wilson is a six-month old silver Lab who is learning the ropes to be a boat dog and help his "dad" Baren Yurchick in the shop *and* at sea—lobstering in the *Kimberly Alison* out of Stonington, Maine. Already weighing in at sixty pounds, Wilson is going to be one big dog, all the better to haul those heavy traps. When Baren goes fishing offshore in the winter, Wilson stays behind and helps keep the home fires burning for his other parent, Kim Yurchick. (March–April 2016)

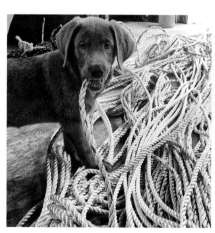 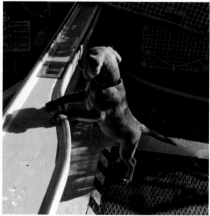

OTIS – he'll sell you a boat

Otis, a two-year-old West Highland white terrier mix, loves boats, particularly those built by the Hinckley Company. His fine taste and affinity for the classic craft aren't too surprising since his owner, Bob Pooler, is brokerage manager for Hinckley in Southwest Harbor, Maine. Otis loves to cruise the coast between Mt. Desert Island and Camden.

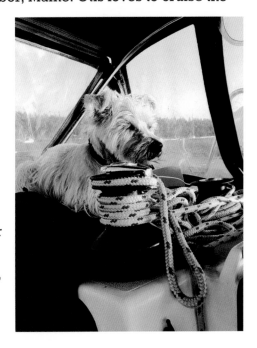

The boat-savvy canine isn't just a Hinckley man, however. He is happy to be seen on other craft, and is shown here relaxing under the dodger on a Tartan 372. He also enjoys freshwater adventures from the deck of a Bayliner 185 on Beech Hill Pond in his namesake town of Otis, where the Poolers have a camp. (May–June 2016)

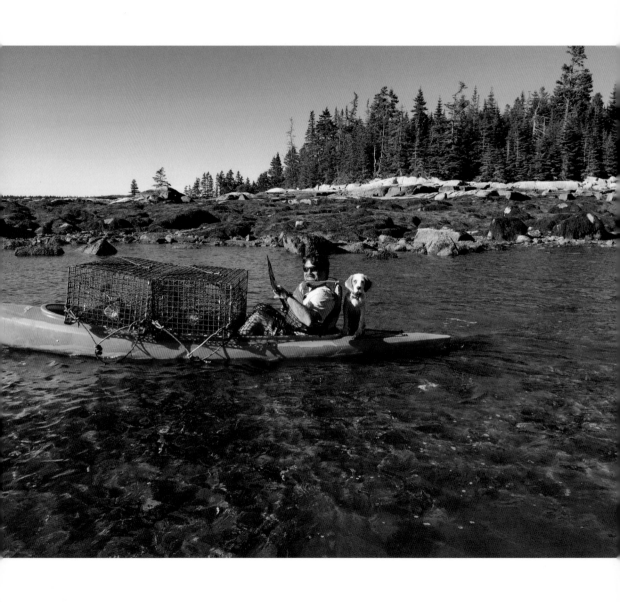

SADIE – legal aide

Sadie has many names, "Sad-Eye Sadie" and "Stubborn Sadie" among them, but her favorite is "Sternman Sadie." A young English setter, she helps her captain, Tony Pellegrini, with his lobstering. He has a noncommercial lobster license and fishes from Great Wass Island in Beals, usually from his sixteen-foot skiff, but sometimes from his Loon twin kayak.

"One September I was heading out in the kayak when Sadie started howling from the beach. She insisted on 'helping' me haul," he said. "We hauled the entire string of traps and Sadie made sure the lobsters were A-OK."

Sadie lives in Holden with Captain Tony (in real life he is an attorney) and Doctor Mumma (trauma surgeon Joan Pellegrini). Sadie has learned "come," "sit," and "heel" pretty well, but she still gets a bit confused between "port" and "starboard." Next summer Tony hopes to have *her* haul the traps, while he relaxes. One can dream, right? (May–June 2016)

BRUNO AND DIESEL – lobstering dogs

Captain Jeremy Alley and sternman Cote Hadlock, both of Islesford, always take their dogs Bruno and Diesel along when they fish for lobster on the F/V *Lobstar* (a 42-foot Duffy).

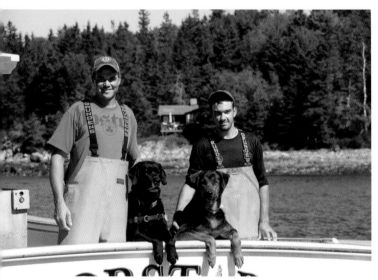

Photo by Jeff Dobbs

"They stay out of the way when we're working," reported Alley, "and in between they chase each other around. We have to keep them away from the bait and lobster legs, though, because they try to eat them."

This photo is part of a project documenting the Cranberry Isles Fishermen's Co-op. The series was part of the Islesford Historical Museum's exhibit "Boats & Buoys: Lobstering on Little Cranberry Island." (Summer 2016)

OTIS AND LUCY – shop dogs

Otis and Lucy are shop dogs in winter, where they diligently help their owner Bob White build cedar and canvas canoes and furniture in Rockport under the name White Woodcraft. During the summer, the two Hungarian vizslas serve as crew aboard *Preamble*, White's Island Packet 37, which sails out of Rockport Harbor.

White describes his business as a "one-man, two-dog operation," but they don't really do much to help, he said. "Mostly they sleep, although Lucy does occasionally gnaw on a scrap of wood." (September–October 2016)

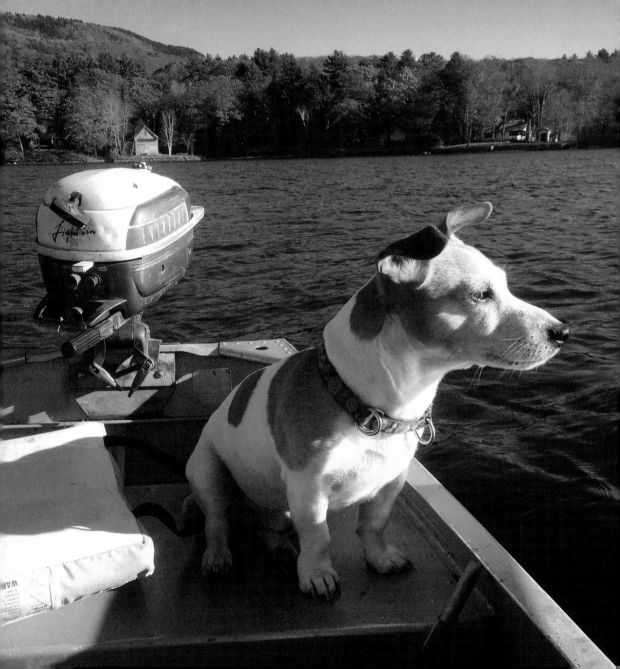

DOGS AT PLAY

SADIE – diver

Here's Sadie, who entertains her Brunswick neighbors with dramatic dives after sticks and tennis balls thrown into Maquoit Bay. She always takes the shortest route between the docks and the object of her attention, effortlessly vaulting over any boat that stands in the way. Sadie has taught several of her canine friends the finer points of diving and retrieving, and although some can outswim her, none has yet matched her aerial form.

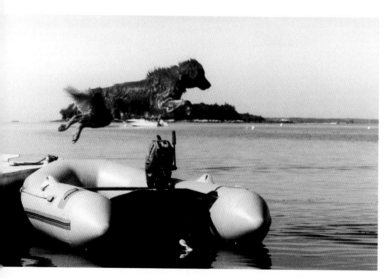

When not retrieving tennis balls and sticks, Sadie goes for long swims with her owners, Marge and Bob Healing, and on frequent walks down to her favorite boatyard—the Smith Boatyard.

(June–July 2004)

LOUIE – at home in many worlds

Llewellyn Sullivan, better known as "Louie," pilots the committee boat at the annual Boston Antique & Classic Boat Festival. He is also one of the judges—*The* judge, to his way of thinking.

That's because he's of the marine breed, a strong agile type with a low center of gravity that easily finds the way on, in, and around the water, no matter the conditions. He sails, he motors, he leads the parade. Louie's given name, Llewellyn—noble in certain New England yachting circles—is a reminder of his Welsh corgi ancestors; while his surname Sullivan, suggests a bare knuckled image from Boston's working waterfront. As a result, he's just as at home chatting up the ladies of quality at the club as he is bending an elbow with the boyos down at Houlihan's Irish Eyes Saloon. (Autumn 2004)

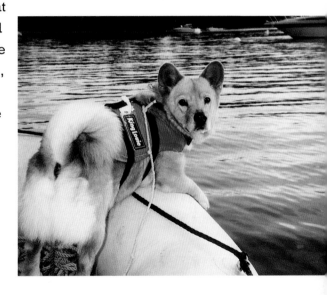

MOOSE – a model dog

Moose, a yellow Labrador, has all the attributes of a full-time boatyard dog, even though he's a part timer, says his companion, Bob Knecht of Cousins Island. "Moose spends a goodly amount of his life during spring boat-prep sleeping under the boat when he isn't roaming around the yard scrounging sandwich parts from other boat owners.

"Being a true Lab, he is a great yard diplomat and does a sterling job of zealously greeting anyone who will make eye contact with him. He's a salty dog too. Nothing suits him more than hanging his head over the gunwale of our Beals Island 22 at 30 knots, head into the wind, taking blasts of sea air up each nostril, his ears flapping for takeoff."

On land, when Moose visits downtown Freeport, he is sometimes mistaken for one of the dog models in the L.L. Bean catalog. "My son and I have been known to claim that he is," says Knecht, "but if the truth be known, the closest Moose ever came to being associated with L.L. Bean was back in 2002, when he ate their spring catalog." (June–July 2005)

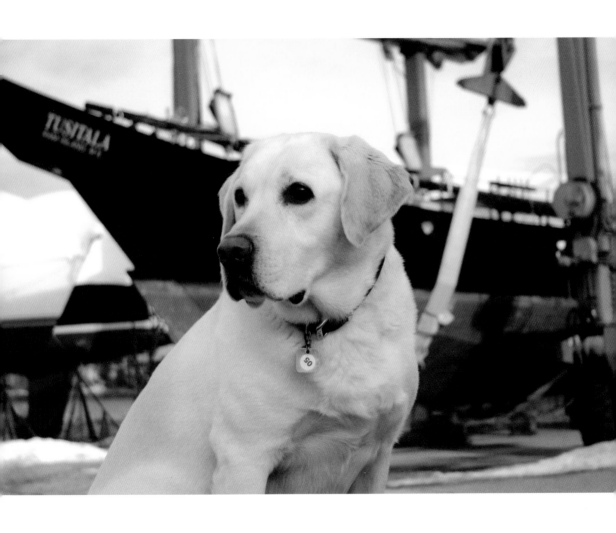

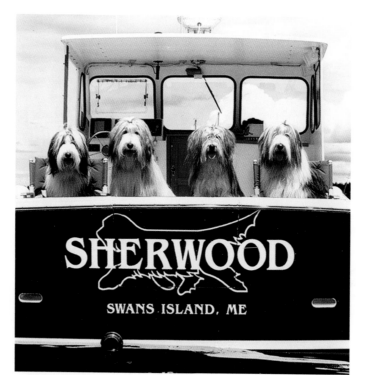

SHERWOOD

SWANS ISLAND, ME

Photo by Donna Wiegle

BEARDIES – good for boat cleaning

"Beardies love boat rides," writes Debby Ritchie, of Swans Island, Maine, and Rydal, Pennsylvania, which could easily explain why her husband Burt chose an AJ28 when he was looking for a new boat.

Built by Alan Johnson of Winter Harbor Marine, *Sherwood* has plenty of cockpit for Quigley, Galen, Libby, and Cricket, four bearded collies who provide two essential functions when the Ritchies are out on the bounding main—companionship and cleanup.

And how is the latter accomplished? First you soak 'em down. Then you suds 'em up. Then you say, "Okay, boys and girls, lie down on deck and roll over," and as soon as they do, you throw the boat into a series of power turns and they'll slide to one side of the deck and then to the other, back and forth until the deck shines like waxed marble. Then you hose the suds off the dogs, blow 'em dry with a few more power turns at full throttle, and line 'em up for a portrait. They're clean, the boat is clean, and all is right with the world. (Autumn 2005)

JOCK – bark alert

"Jock is a Cairn terrier with a mission," says Bill Hawthorne, of Deer Isle, Maine, and Wayland, Massachusetts.

Jock, it seems, has a boat jones. Show him a boat, and he'll make a bee-line for it. Don't show him a boat, and he'll stand on the shore and bark until you do. "In Deer Isle," says Jock's pal Bill, "he'll spend hours looking longingly across Eggemoggin Reach to Brooklin Boat Yard in Center Harbor. Sometimes he sits on the shore and barks at passing lobstermen in the hopes they will ferry him across the Reach to the boats on the other side."

Terriers, as we all know, are happiest when they are barking, which is a good thing for Bill Hawthorne, especially when out on his boat with Jock during the thick-o'-fog. In that event, Jock takes up position in the bow and becomes a four-legged fog signal to warn off other boats in the vicinity. In the thick-dungeon-o'-fog, when Bill can't see three inches beyond the tip of his nose, Jock's barking at least tells him where the pointy end of the boat is and thus where they are going.

(February–March 2007)

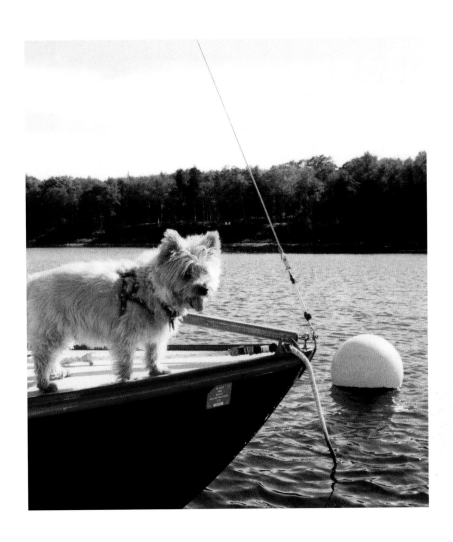

SKIPPER – from away

Skipper is a salty little dog. He lives on Hodgdon Island, down Boothbay way, where the local dockwallopers let him think he's in charge of the waterfront. In reality he isn't, because deep down inside they know and he knows that he has a fundamental flaw: his place of birth. Born in Arkansas and shifted about for reasons unknown, Skipper was rescued from a pound in that state and eventually brought to Maine. In other words, he might look like a salty little Mainer, and he might act like one, but the truth is, he's not. He's From Away.

But don't be fooled. Mess with him on the docks at the Boothbay Region Boatyard, or, most especially, mess with his boat, the Albin 28 *Tournament Express Curmudgeon*, and you'll find out pretty quickly that he might be a terrier mix from the hinterlands, but he's a tough little customer nevertheless.

What's more, he's internationally famous: the first officially sanctioned *Maine Boats, Homes & Harbors* Boatyard Dog® with his own United States Postal Service commemorative stamp.

(April–May 2007)

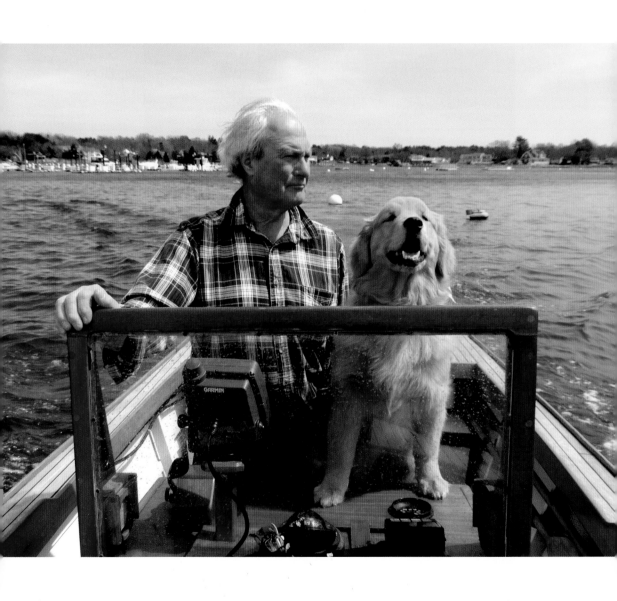

ELOISE – eagle-eyed assistant

Eloise is a three-year-old golden retriever, who serves as first mate on outings with Allan Vaughan near their summer home in Pretty Marsh, Mount Desert Island. The boat, by the way, is a wooden 18' center-console runabout built by Vaughan in 1989. In addition to making sure Allan has his boat, *Chasing Wabbits*, under control, Eloise keeps an "eagle eye" out for eagles, as well as porpoises and seals on warm summer days. "We love Maine and so does Eloise," says her fellow first mate, Gail Vaughan. (January–February 2017)

MOLLIE – a dog of the water

Nobody needs to be reminded that Labrador retrievers are water dogs. So, too, are goldens, springers, cockers, and poodles (when they aren't hanging around the beauty salon). You want proof? Take a look at Mollie, an archetypal yellow Lab.

Here she is, only eight months old, and she has already logged 200 hours underway at sea. Her first voyage came when she was only eight weeks old. Apparently, she'll go boating early in the spring and late into the fall when the rest of the family won't, and spends most of her time as lookout at the bowsprit.

"Mollie is not, technically speaking, a boatyard dog," said her captain, Jeffrey Jordan, "but she loves boating. Her favorite spots are on the aft deck, the cabin top, or sleeping on the warm engine cover." Which is not, technically speaking, totally accurate. Mollie is, after all, a dog of the water, and her favorite place is up to her neck in it. (March 2010)

RADAR – deep diving dog

There are those who might think that a pool-diving dog—gainers, cannonballs, back flips, forward somersaults with a twist—would be too effete, too pampered to be a true boatyard dog. (The image is of jewel-encrusted drinking bowls and attendants with soft Turkish drying towels.) But not our boy Radar. His lineage is impeccable.

A full-bore black Lab, his mother was the late Dory of Fishermen's Wharf and his father is Tug of Lewes Harbor Marina, a hop, skip, and a jump down the road from each other in Lewes, Delaware. One soft summer evening Tug moseyed on up the road and . . . well, we all know what happened next. The result of that clandestine rendezvous was a rather large pile of boatyard/marina puppies. Radar was among them.

"Radar takes his heritage very seriously," wrote owner Donna Floyd. "He began swimming when he was six weeks old. By five months he began diving in the pool to retrieve anything he could find on the bottom. Maybe we should have named him Sonar." (May 2011)

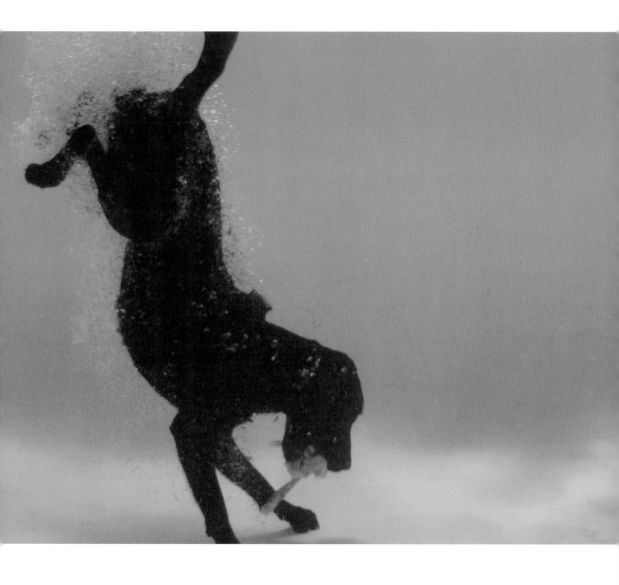

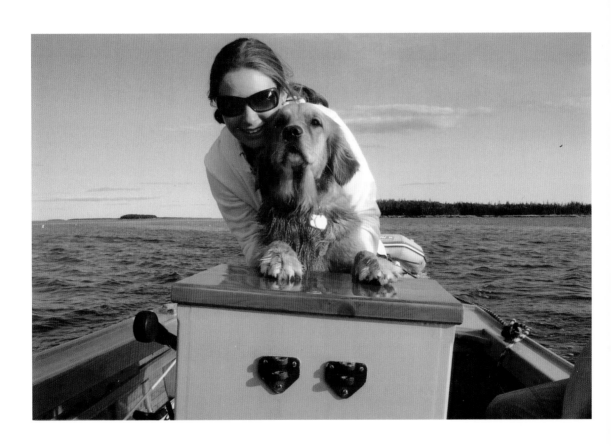

MISTY — co-pilot

Okay, we give up. Who's driving? The blonde with the black nose or the brunette with the sunglasses? But then again, does it really matter? After all, it's a beautiful day on the water in Southeast Harbor, Deer Isle, and that's a Pulsifer Hampton launch, and you know the type—no matter who is at the wheel, a Hampton can just about take care of itself. Here are the particulars:

The boat—*Eastern Mark*, 30 years old.

The brunette—Lisa, 19 years old, daughter of the boat's owners, Mark and Betsy Gabrielson of Deer Isle.

The blonde—Misty, 5 years old, golden retriever, "without a doubt the family's best lookout for seals, birds and lobster pot buoys." (June–July 2011)

KASSIE – unofficial yachtyard dog

Brittany spaniels aren't particularly known as water dogs—they're pointers, favored primarily for upland bird hunting—but Kassie, a Brittany belonging to Kem and Carol Siddons, spends quite a bit of time on the water, if not in it. Twelve years old and as chipper as ever, she spends her winters in Jacksonville, Florida, and her summers in Brooklin, where she is reputed to be the unofficial yachtyard dog for the Center Harbor Yacht Club.

While a bird dog at heart, she loves to roam the docks around Center Harbor and, whenever possible, go rowing or sailing. She has even ventured out in a kayak a time or two. An early riser, she joins Carol on walks along the shore and helps her sniff out sea glass. Her big adventure last summer was getting to roam around Marshall Island while visiting Stuart, the Siddons's oldest son, who worked there as island caretaker. Kassie is definitely a Mainer at heart and an integral part of the summer boating life in Brooklin. (Summer 2011)

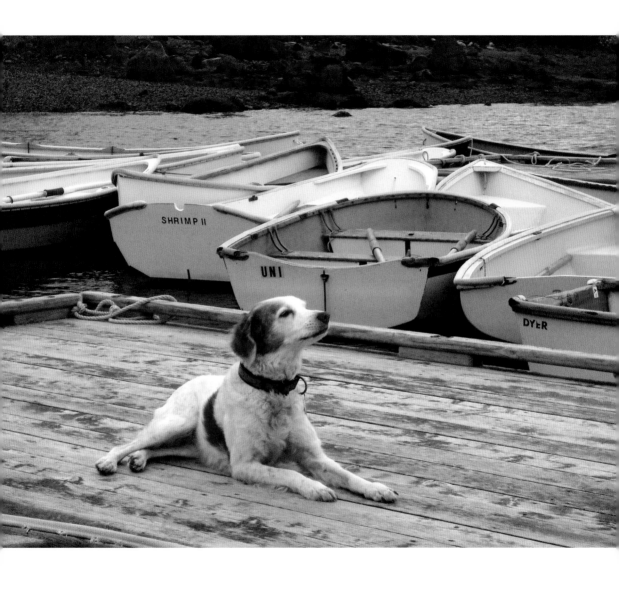

RADAR O'REILLY – loving the lake life

Known as Radar to his family and friends, this dog may hail from Baton Rouge, Louisiana, but he spends his happy time on Clary Lake in Jefferson, Maine. We say "on," because Radar is a most unusual black Lab: he doesn't much like being "in" the water. But he does like being in a boat, which is a good thing, because the crowd he hangs around with likes to do the same.

"Radar has a wonderful story," wrote Kate Grant Seba. "Our two daughters found Radar wandering our neighborhood on December 28, 2004. He was skin and bones and very skittish. They coaxed him to our house, where he happily dined on Cheerios until I could get to the store to buy dog food. After posting signs and putting an ad in the paper and receiving no response, we decided he was ours. We took him to the vet, only to find out that he had every worm possible. We decided to take the financial plunge and do what we could to save him. Now, seven years later, he is a highly valued member of our family! He is the only black Lab (I would imagine) that doesn't bark, and is the most loyal pet anyone could ask for."

(June–July 2012)

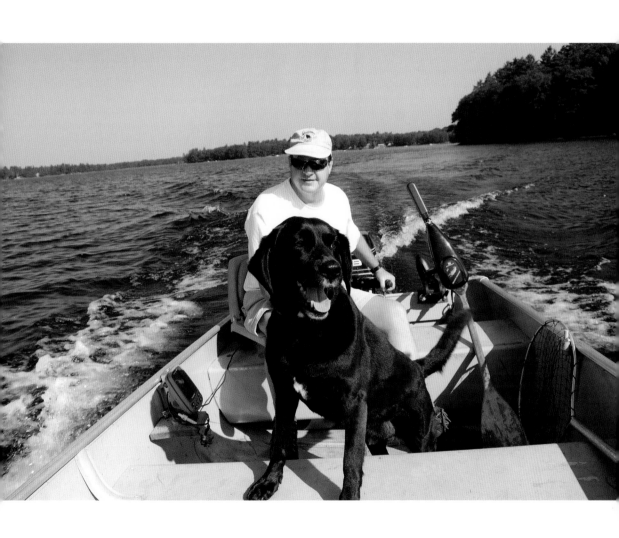

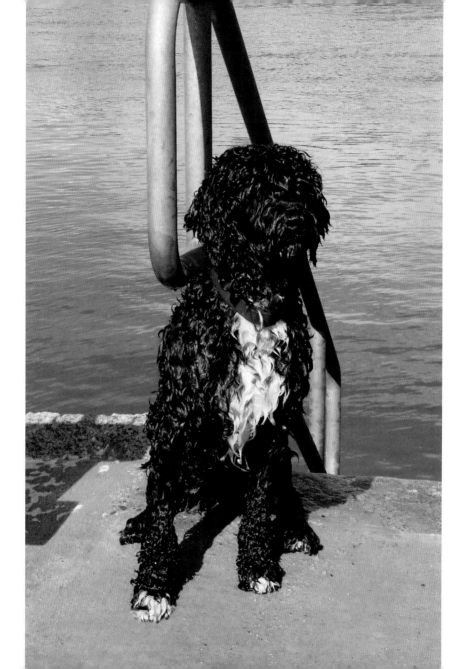

DICKENS – water loving

Dickens was born on Cape Cod and moved to Portsmouth, New Hampshire, at the age of eight weeks. On his first day there, while wobbling around the dock, he unintentionally ended up in the water of the Back Channel and has proven his water dog heritage ever since. He spends as much time as he can aboard his people's 32 Holland or swimming and retrieving tennis balls at Peirce Island, a convenient nearby location. His two-legged companions (Eleanor, Pete, and Carol) have been loyal readers of *Maine Boats, Homes & Harbors* for many years. Although Dickens may never be as agile as some of those dogs at the Boatyard Dog Trials, at two years and four months, he still has time! (January–February 2017)

DORY – the duck toller

This Nova Scotia duck tolling retriever works as second mate, deckhand, and chief engineer in charge of prop-monitoring. She does all this aboard her family's Webco 22 named *Beach-comber*, which she graciously shares with crewmates John and Nicole Gray of Sedgwick, Maine.

What is a duck toller, you might ask? We didn't know either, so we went to the font of all knowledge (Wikipedia) and learned that these dogs were bred to cavort in the shallows to lure ("toll") unsuspecting ducks and other wild birds. The curious birds come in close to see what in quack that crazy dog is doing, the hunter stands up, and, well, you can guess the rest of the story.

Dory is a boat dog, through and through. In her first two years she has already circumnavigated Swan's Island, Marshall Island, and Isle au Haut in the family boat, and she also loves to visit Hog Island, where she helps with beach cleanup by retrieving lost lobster buoys. A true salt, Dory enjoys all her jobs and, being the talkative sort, loves a good gam. (May 2013)

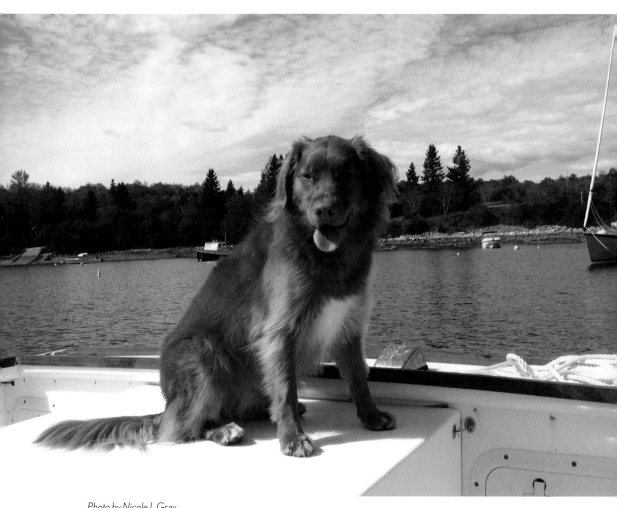

Photo by Nicole L Gray

FIONA – of Loch Ern

Fiona was a wee lass, just seven months old and seven pounds heavy, when this photo was taken on a friend's boat, the Hinckley B40 *Manuela*. A comfortable winter in South Carolina helped her reach her fighting weight (eight pounds), perfect for fitting comfortably on the dash of her boat, a Back Cove 29 named *Water Sky*. Once in Bass Harbor for the summer, Fiona supervises all work done by Up Harbor Marina, which maintains her boat, and presides over informal Bass Harbor Yacht Club meetings on the dock as part of her many duties.

Photo by Mimi MacNeish

Celtic sweater aside, you might not guess that this toy Manchester terrier is Scottish through and through, but och aye, it's true! She's a MacNeish, with a registered name: Celtic Cross' Fiona of Loch Ern, which is longer than she is. Her clan nominated her to be a boatyard dog because in addition to having a grandchild-tolerant nature, she loves people and cruising in company with other good-looking classic yachts. (June–July 2013)

RUFUS – co-author

Rufus is an 8-year-old cockapoo (a cocker spaniel poodle mix) who has sailed much of his life, mostly on Penobscot Bay, with his owners Robin and Tamara Lloyd of Camden on *Galatea,* their 38-foot L. Francis Herreshoff ketch. The author of the historical novel *Rough Passage to London*, based on an ancestor who was captain of a 19th-century transatlantic packet, Robin is hard at work on a new book about Civil War–era blockade runners. No word yet on whether Rufus will play a role. (February–March 2017)

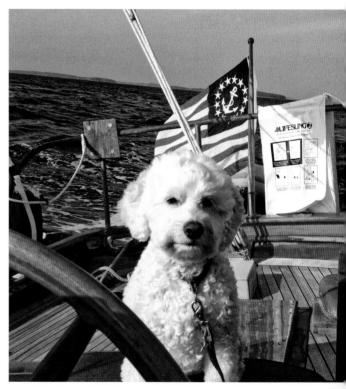

BUFFER – chief mate

The 'buffer' is a colloquial term given to the chief boatswain's mate on a Commonwealth Navy ship. Scott Thomas, a retired Canadian Naval Officer and former captain of a 154' schooner was therefore used to having a buffer on board. So when he and his wife, Pamela, got a chocolate labradoodle puppy, they named him Buffer. He races regularly in Portland Harbor on the Thomas's J/35 *Sugar Sugar* and their Etchells 22 *Fotofinish*. Ashore, Buffer helps at the family business ARTiPLAQ, which mounts nautical charts and other custom images. (April–May 2015)

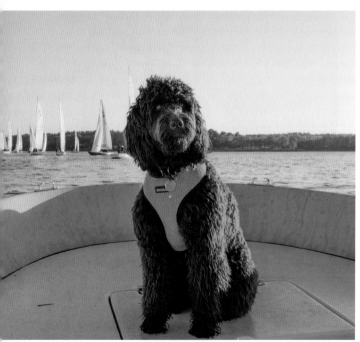

Photo by Anne Blanchard

RILEY — living the good life

Riley, a soft-coated Wheaton terrier, truly lives the "life of Riley." He spends summers with his family, the Masseys, in Biddeford Pool and has been boating for his entire life (ten years). When his life jacket comes out, he knows where he's going. A great day for Riley involves time on the *Marion B*, the Masseys' 28' Cape Dory trawler, from which he watches the buoys, the birds, and the waves. He and his family spend winters in Naples, Florida, boating whenever they can. If that's not living the "life of Riley," we don't know what is!

(June–July 2015)

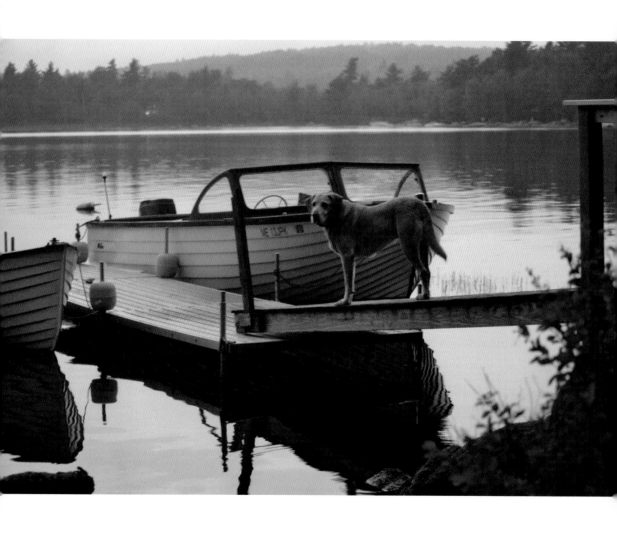

COBBIE – the diving dog

Cobbie (short for Cobscook) is a 12-year-old yellow Lab and the constant companion of Jake and Sue Ward of Hampden and Ellsworth, Maine. He is shown here on a classic 1957 Old Town 18' Ocean Model that belongs to his people, but he is at home on a variety of vessels ranging from a 13' Whaler to a tandem sea kayak.

Ideally, though, he would rather go swimming than boating. Cobbie grew up entertaining himself by dropping tennis balls off the dock and fetching them, over and over. At some point, he began to chew holes in the balls so they would sink, then he would dive to the bottom to retrieve them.

(June–July 2015)

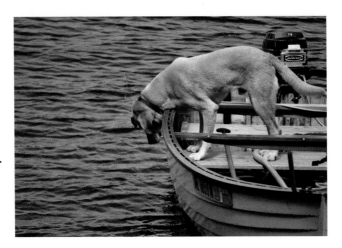

PATTIE – playing it safe

Pattie's a newbie, and not a swimmer, but that didn't stop this stalwart dog from taking a two-day boat ride last fall from

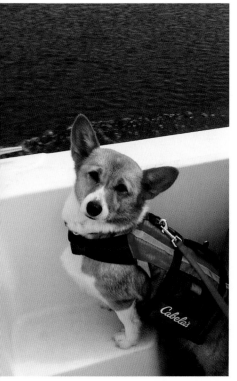

Spruce Head to Boothbay Harbor, through Townsend Gut, up the Sasanoa River to Bath, and the Kennebec River to Augusta and back. It was her first time on the water, and she wore her life jacket as a precaution, as all boater dogs should. She was accompanying her colleagues, Susan DeWitt Wilder and Paul Austin of Scarborough, Maine, on a friend's 21-foot Parker powerboat. Pattie practiced her sea legs again this spring on Jarrett Bay in North Carolina, accompanying her humans on another short cruise. When the three boats in her own backyard ("boatyard") in Maine eventually get restored, she'll be spending even more of her time on the water, always wearing her life jacket, of course. (Summer 2015)

JACKSON – boater not a swimmer

Jackson is a nine-year-old southern gentleman. A corgi-basset mix, he is a rescue dog from Georgia. Being barrel-chested, he has no desire to swim in Crystal Lake in Gray, Maine, where he lives with his family. However, that doesn't mean that Jackson lacks an affinity for being afloat. When he sees his owner Debbie Uva get into the paddleboat, he gets quite excited. He even has his own seat. Actually, Jackson loves to cruise along on the lake so much that it is not easy to get him back on dry land. (January–February 2016)

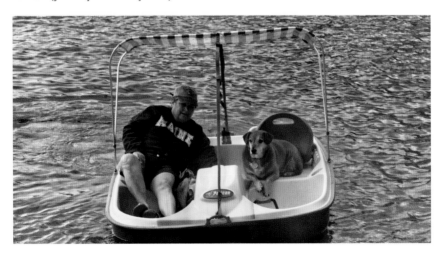

GILMORE – flying dog

Gilmore is a three-year-old terrier-Chihuahua mix. Rescued from a shelter in Ft. Worth, Texas, this lucky pooch now splits his time between Damariscotta, Maine, and the Chesapeake Bay region.

When in Maine, Gilmore enjoys sailing on a 20-foot O'Day as well as kayaking with his family. A regular passenger on the Hardy Boat ferry to Monhegan, Gilmore is always up for saying hello. And he's happy to greet familiar locals and visiting tourists alike. Gilmore also likes to fly—did we mention this dog's luck?—and takes to the skies with his family in a vintage Cessna 170.

(March–April 2016)

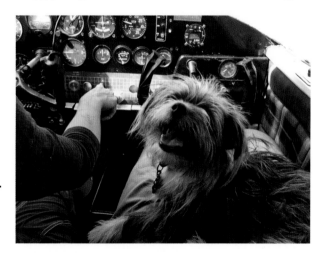

MAXIE MOXIE – trimaran crew

Since puppyhood, the mini schnauzer Maxie Moxie has been a water dog. She has sailed with her person, Francis Waters, on a 25-foot Elan trimaran, kayaked in Maine and Florida, and been first mate on numerous rowing adventures in an Iain Oughtred dory.

Although she's not an overly enthusiastic swimmer, she happily shows off her aquatic skills when necessary. Maxie Moxie enjoys the trimaran's many comfortable resting spots, and particularly favors stretching out on the trampolines, though a folded sail cover or a boat cushion will do as well. Here, she relaxes after an exploratory mission to Little Whaleboat Island, which she has deemed her favorite of the many in Casco Bay. (Summer 2016)

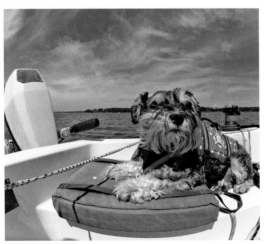

Photo by Benjamin Brierley

PASHA – traveling greyhound

Pasha, a 7-year-old Italian greyhound, splits his time between a boathouse on the New Meadows River and the *Jenny Ives*, a 37-foot wooden gaff ketch built by Roy Blaney in Boothbay Harbor. Pasha has cruised the coast from Portland to Bar Harbor with his people, Rachael, a potter, and Colby, a boatbuilder. His adventures along the way have included crashing a lobster bake at the WoodenBoat School and summoning seals to the dory while rowing in Port Clyde. He even gets to cruise with his people when they sail the *Jenny Ives* to the Bahamas in the winter. (September–October 2016)

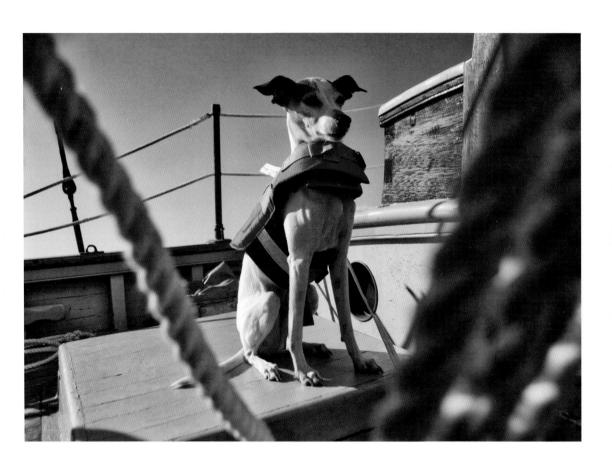

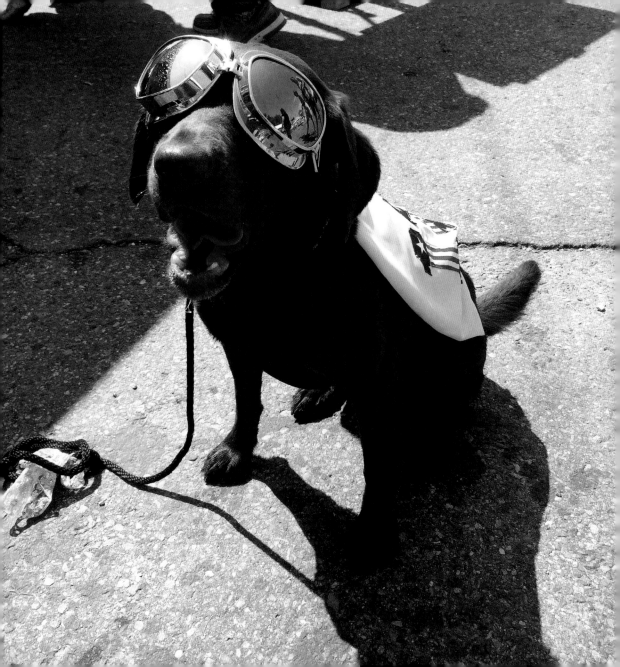

DOGS SHOWING OFF

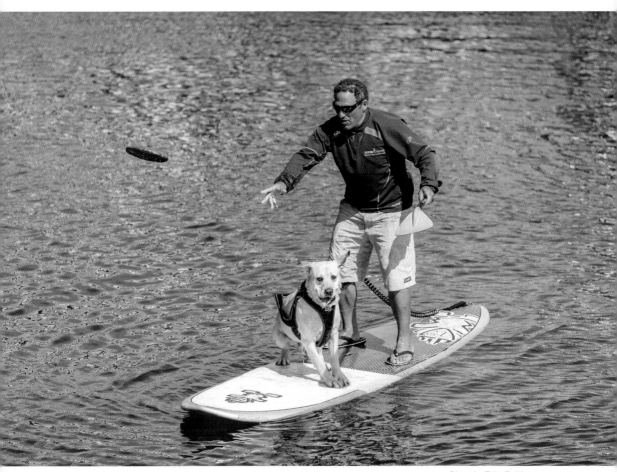

Photo by Tyler Fields

WORLD CHAMPIONSHIP BOATYARD DOG TRIALS

The first annual World Championship Boatyard Dog Trials was held on a glorious late August day in Camden, Maine, as part of the town's annual Windjammer Days celebration. Salty dogs vied to take home the coveted Pup Cup. The contest included three parts: first, the dogs ran an obstacle course along a floating dock and over buoys, lobster traps, an inflatable dinghy, and other gear, then they climbed in and out of a tippy dory. Finally, each dog jumped (or was "helped") into the water to retrieve a stick or ball thrown by its owner.

The contest moved to Rockland, Maine, the following year, which was when *Maine Boats, Homes & Harbors* held its first annual boats and homes show. The contest was similar: The dogs had to make their way through a lobster-trap obstacle course, jump in and out of a very tippy dinghy, and leap into the cold harbor. Judging was based on rules that explicitly stated that "there were no rules" and that "cheating is not only acceptable but encouraged."

SAMPSON AND RILEY P. DOG—
a championship tie

A large, enthusiastic crowd
was on hand to cheer as Sam-
son and Riley P. Dog tied for
the 2003 title.

Rylie P. Dog got a perfect
score by acing all events with
a finesse that even the black
Labs in attendance had to
admit was stylistically pure.

Sampson, on the other
hand, just wouldn't go into
the (mighty) cold water
after the thrown stick, but
received a perfect score

Photo by Jeff Scher

anyway. That's because his handler jumped into the water,
retrieved the stick himself, and then cheated his way into a tie
in a manner that, while not stylistically pure, was a masterful
study in shamelessness. How? He bribed the judges right out
in the open with a cooler full of soda, beer, and candy, and

then sealed the deal with a manly man's kiss for judge Lucinda Lang.

Was this a Boatyard Dog Championship to remember? Does a bear poop in the woods?

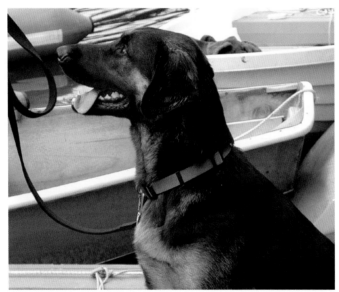

Photo by Rebecca Taylor

BORIS BEARENAUF — lumbering to the top

The Boatyard Dog of the Year for 2004 was Boris. He won in lumbering fashion. Boris may look like a manly man (he weighs in at 110 pounds) but he's only a boy—less than a year old when he took the title. A Newfoundland with a hindquarter problem, he was brought home as a young lad by Carlton Johnson of Redfern Boat in Lamoine, who recognized his potential. Boris may not be a ballerina, but he's light enough on his feet to handle docking lines at Redfern and redistribute wood in the boatyard scrap pile. He is also the only boatyard dog we have run across who can tie a knot, a skill that helped put him over the top at the trials.

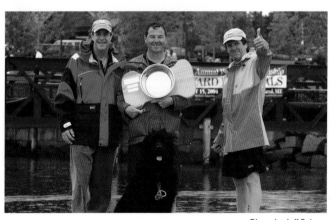

Photo by Jeff Scher

SOLDADO WOOLLETT – lobster crate speed demon

The winner of the 2006 World Championship Boatyard Dog Trials was Soldado Woollett from South Thomaston. A Culebrense by blood (she was rescued from the island of Culebra, Puerto Rico) Soldado wowed the judges and the crowd by running a string of lobster crates with blinding speed.

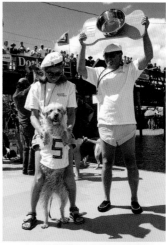

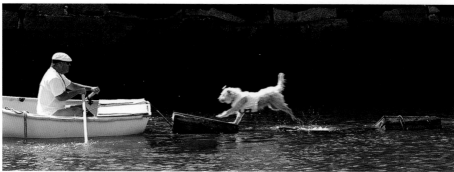

Photos by Jeff Scher

JAKE – old dog with a new trick

In theory you can't teach new tricks to old dogs. In practice, however, you can, and as proof of that we have Jake the Sailor Dog, winner of the 2005 trials at the Maine Boats, Homes & Harbors Show. Two years previously, at the age of seven years, Jake entered the trials and lost to a pair of much younger dogs. Was he disappointed? Yes. Did he give up? No.

In 2005, at the advanced age of nine years old, representing Great Island Boatyard, Jake smoked the competition. He leaped the lobster traps, he jumped into the tippy boat and climbed back out again, he retrieved the stick from the icy waters of Rockland Harbor. And in the freestyle event he wowed the crowd by demonstrating something an old dog wasn't supposed to be able to do—he had learned a new trick. Jake's chum Barbara Hart jumped into the harbor and tossed a line to the dock where Jake was standing. Jake grabbed the line and pulled Hart to safety. To seal the deal, Jake instructed his chum to bribe the judges with a batch of homemade cookies, which she did.

Jake was a hit, Hart was a hit, the cookies were a hit—one judge said *sotto voce* that they were the best bribe he had seen

since the pumpkin flavored whoopee pies at the Olympics—
and the trophy was duly awarded to an old geezer with heart.

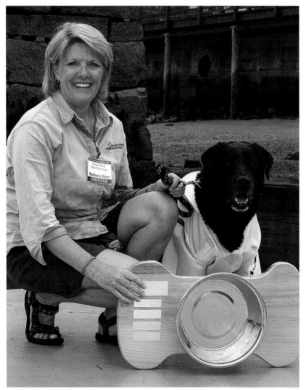

Photo by Jeff Scher

TRUMAN – and his team of secret agents

This 2008 World Champion Boatyard Dog is a young and energetic bloodhound. He was entered into the trials by the Humane Society of Knox County and teens from Youthlinks, a nonprofit youth organization in Rockland, Maine.

Truman entered the competition as "Mystery Mutt, a.k.a. Agent K-9," handled by "agents" from Youthlinks. The teen agents had a dual purpose in mind: They wanted Agent K-9 to win, but they also hoped that the exposure would help Truman (his real name) find a permanent home.

Truman and his agents went through rigorous preparation with professional dog trainer Marie Finnegan before the competition. Then, to the sound of theme music from James Bond and the Pink Panther, Truman cleared an obstacle course, leaped from a tippy dinghy, disarmed secret agents, kissed a femme fatale, responded to commands in a multitude of languages, knocked a villain off the dock, and then resumed cover as an everyday family and dog. After a tie-breaking performance, audience acclaim clinched the championship for Truman and his Youthlinks teammates.

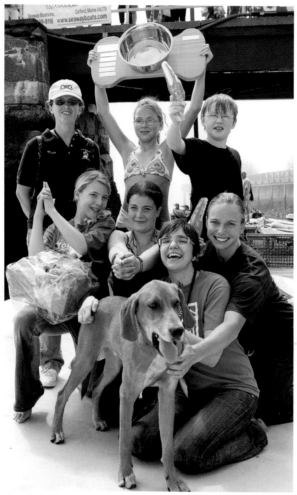

Photo by Jeff Scher

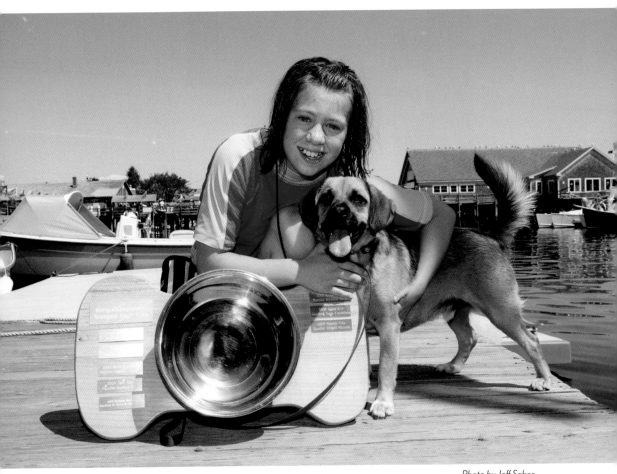

PANCHO VILLA — staying dry

The 2009 World Champion Boatyard Dog was a two-and-a-half-year-old "puggle" named Pancho Villa. This cross between a pug and a beagle was handled by young Abigail Matlack. First, and in keeping with this zany competition's long-standing tradition, Abigail and Pancho shamelessly bribed the judges in front of the crowd.

The pair then aced the obstacle course, with Abigail climbing over the lobster crates and Pancho going under them. Getting in and out of the very tippy dinghy was a snap for this salty duo. Then, for the freestyle segment, Pancho rode on the bow of a windsurfer, watching out for pirates while Abigail paddled them around the harbor.

The only aspect of the competition that proved troublesome was the requirement that either dog or handler must finish soaking wet. After a brief consultation, Abigail agreed to jump into the chilly waters of Rockland Harbor. Pancho later told show judges, "I do *not* swim, it runs my mascara."

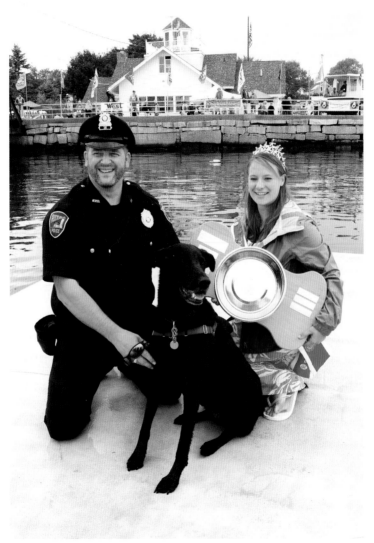

Photo by Jamie Bloomquist

FENWAY – police dog

One of the tenets of the Boatyard Dog Championships is that cheating is encouraged, which proved a challenge for the 2011 winner, Fenway. Fenway was assisted by her owner, Joel Neal, who happens to be a police officer.

Perhaps it was the sight of a policeman being thrown in the drink by a dog, or maybe the judges were swayed by the "Get Out of Jail Free" passes and Dunkin' Donuts gift cards they received as bribes, but the pair wowed crowd and judges alike. Their speed through the obstacle course and agility into and out of a very tippy boat during the "Dinghy Hop" portion of the trials were notable. A critical component of the competition—that either dog or handler must end up soaking wet—provided lots of laughs. Neal stood on the edge of the dock with the obligatory rubber duck clenched in his teeth. When Fenway leaped up to get the duck, she pushed him over backwards into the water.

Here, the 2011 Maine Sea Goddess, Kristen Margaret Sawyer, presents the coveted Pup Cup to Fenway Officer Neal.

OTTER – swimming poet

When the fur, hula hoops, margarita mixes, lobster and donut bribes, and sombreros were done flying, there was a clear winner at the 2012 Boatyard Dog Trials: a fine specimen of the black Lab-ish kind named Otter and her young handlers Phoebe and Jane.

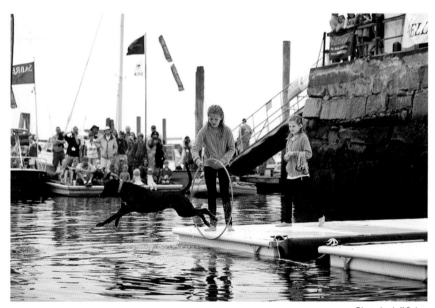

Photo by Jeff Scher

Of the competing teams of dogs, Otter was the only one to willingly go in the water. In fact, the challenge was to convince her to stop swimming long enough to perform her dockside tricks. Otter is a poet, and plans to use her win to further her pawblishing endeavors.

Photo by Jeff Scher

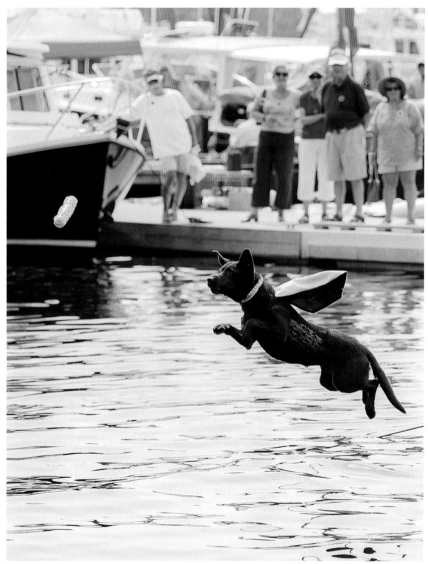

Photo by Debra Bell/Bell's Furry Friends Photography

GATSBY – a Lab who can "fly"

Gatsby, a rare, flying chocolate Lab was the 2014 World Boat-yard Dog Champion.

Gatsby edged out the competition by acing the mandatory parts of the contest with ease, then launching into a series of incredible high-flying jumps—and what flying super dog would be complete without a cape.

After a second-place finish last year, Gatsby was determined to parlay her love of water, jumping, tennis balls, and swim-ming into an irrefutable win—and her hard work paid off.

ZEPHYR – making a big splash

Meet Zephyr, a three-year-old, English-style yellow Lab from Owls Head who was the winner of the 2015 World Championship Boatyard Dog Trials.

While there were several standout acts—a knot-tying pug that cleated off a line; a rescue Chihuahua who swam despite a strong hatred of the water; a high-flying chocolate Lab that

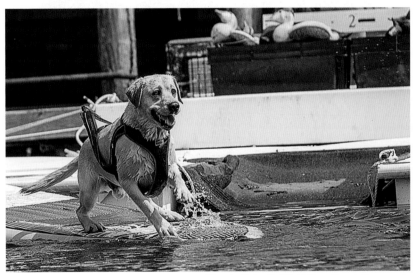

Photo by Debra Bell/Bell's Furry Friends Photography

caught the Frisbee in mid-air!—Zephyr and his owner, Tony Fitch, edged out the competition with their sheer exuberance and paddle-boarding skills.

English Labs are said to be somewhat smaller in stature than their American cousins, but Zephyr made a big splash with the judges.

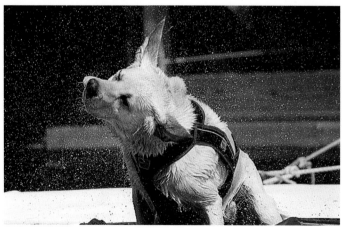

Photo by Debra Bell/Bell's Furry Friends Photography

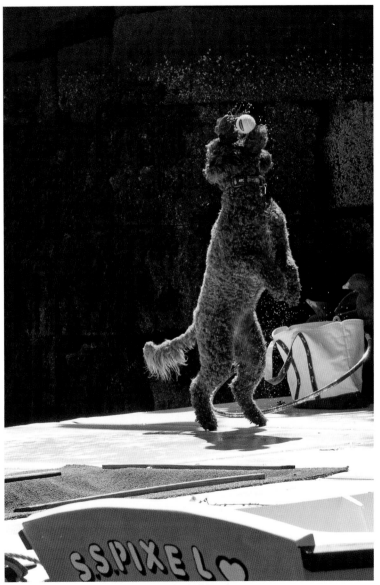

Photo by Debra Bell/Bell's Furry Friends Photography

RUFFLES – hula hooping champion

When the fur finally stopped flying, a Portuguese water dog named Ruffles had won barking rights as the 2013 World Champ.

Ruffles spends as much time as possible at Olson's Wharf in Cushing chatting up the lobstermen, riding in her kayak, and chasing rocks and ducks. She got near-perfect marks during the required parts of the competition—the Dockside Obstacle Course and the Dinghy Hop. Then she performed her freestyle routine with both a hula hoop and the required tennis ball. In the end, her unleashed enthusiasm (and her handler's willingness to join her in a swim) garnered her the lead over a tight field.

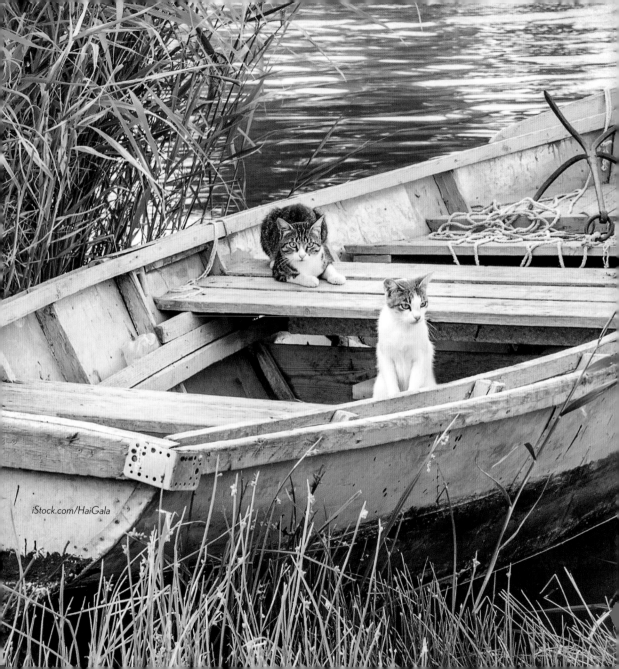

THEY WISH THEY
WERE DOGS

TIKKI – cutter cat

Maine Boats, Homes & Harbors editor at large Gretchen Piston Ogden has been sailing south this winter with her husband Michael and their boat-cat, Tikki, aboard their steel cutter *Syrinx*.

Tikki can't speak or hold a pen, of course, but if she could, here's some advice she'd offer to other feline (or canine) readers if they consider running away to sea. First, realize that the transition to living aboard might be more difficult for your humans than for you. Realize that it will take time for them to find their sea legs and try not to take it personally when they step on your tail. Help them adjust by drawing upon your innate diplomatic talents—your ability to mediate and interpret will do much to ensure harmonious discourse on board ship. Make things easy for your fellow crewmembers. Eat everything that is put in front of you. Keep your bunk neatly made up. Stow your gear before the ship puts out to sea. Sleep—a lot. Volunteer for night watches. Put your marlinspike seamanship skills to use. All these efforts will go far to ensure you a permanent billet as a bona fide member of the crew.

Is it worth it? If she could speak, Tikki would most likely say yes. Then she would share this little secret: her duties are not

much different now than they were on land. She eats, she sleeps, she plays, she entertains the crew, she sleeps, she eats

(March 2014)

PILAR – boatyard bird

We know it's difficult to imagine—in fact, there are those who believe that what we are doing is wrong, Wrong, WRONG—but this boatyard dog is in fact a bird. Actually, it's a parrot, in particular a Hahn's Macaw (*ara nobilis nobilis*), and she spends much of her time on Penobscot Bay aboard *Anudari*, a Roberts 36 cutter owned by Kate and Ellard Taylor. The Taylors sent us these particulars:

"Our pet parrot, seventeen-year-old Pilar, was adopted in 2000. When we moved to Pulpit Harbor, North Haven, with the rest of the family (two boys, their parents, a dog, and a cat), she came with us. She continues to travel aboard *Anudari* between the Penobscot Bay islands.

"On board, Pilar is the cabin alarm clock, chirping persistent, crisp 'Hellos' starting precisely at 6:30 a.m. and ending when the cover is taken off her cage. The tiny animal, a teenager in bird years, entertains her fellow sailors by mimicking a variety of sounds: The deep whir of the diesel engine, shouting 'Whaaaack' as waves strike the steel hull, exclaiming 'Good luck!' when anyone gets into the skiff, and greeting them with 'Ahoy!' upon their return." (February–March 2013)

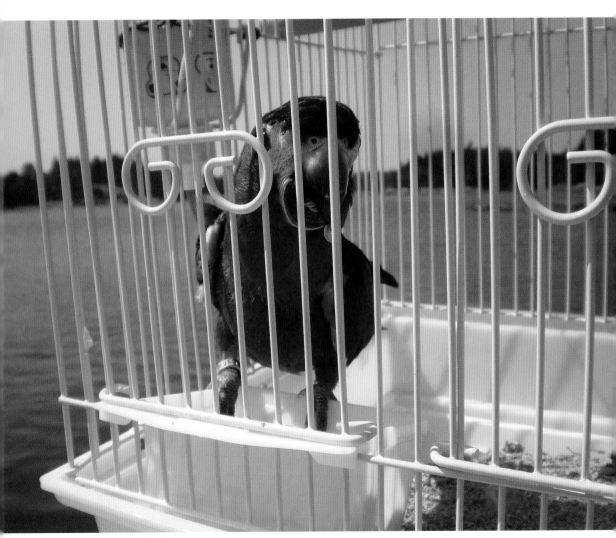

Photo by Kate Taylor

DARTH – black ship cat

Yes, we know. It pains us, too, as it no doubt does all those noble beasts—the Labs, the goldens, the Chesapeakes, the spaniels, even that cute little Shih-Tzu with the twisted marline in her hair—who have graced this page over the years. But we had to do it after Tom Hanson of Orrington, Maine, who with his wife Ann sails their Pearson ketch out of Northeast Harbor, sent us this photograph of their cat with this letter:

"My declaration of 'No More Cats!' was sabotaged when a tiny black fuzz-ball of a kitten attached himself to our back screen door. I blinked first with an offering of food. I blinked second after a little Internet research revealed that an all-black cat is considered good luck on a ship. The kitten, now cursed with the moniker of Darth—he is totally black after all—had to pass a test, however,

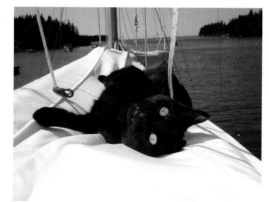

before being accepted into our family: He had to prove his sea legs, which he did during his first encounter with *mal de mer* when he went to his litter box to "call Ralph" rather than making a mess on deck. How could I refuse him after such a

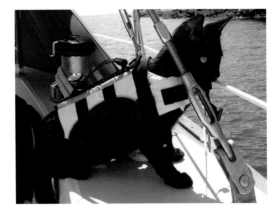

noble gesture? The deal was sealed.

"Darth regularly performs derring-do feats, leaping from boat to dinghy and back, perching with all four paws on a narrow gunwale, or bouncing across the waves without falling into the water. We do, however, have to keep a safe distance away from other boats to prevent him from leaping aboard to explore. One time we didn't, and an innocent boat had to be partially disassembled to retrieve the curious Darth." (April–May 2010)

THE BEETLE – boatyard cat

Following in the paw prints of legions of cats that have gone to sea (historically employed as mousers), former shelter kitten and shorthair classic tabby The Beetle had no idea what she was in for when she was adopted by Captain Bob and Lynette Walther. She spends her summers dividing her naps between a circa 1880 barn in Camden and trips around the midcoast in the 1920s-design motorcruiser *Pelican*. She winters aboard a 53-year-old Willard Vega troller, *Old Salt*, on Florida's St. Johns River and down in the Florida Keys. Though this kitty has earned her sea legs, she has yet to catch a single rodent. One of her greatest accomplishments is that this feline aerial acrobat has never landed in the drink, and has no plans to do so. Instead, The Beetle loves to play fetch, stroll the deck—on the outside edge of the rail, of course—and she never turns down the opportunity for a good belly rub. (March–April 2017)

ACKNOWLEDGMENTS

Thank you to all who helped put together these columns and then compile them into a book, including *Maine Boats, Homes & Harbors* editorial assistant Sarah Moore and managing editor Jennifer McIntosh, as well as former *MBH&H* managing editor Gretchen Ogden and former editor Peter Spectre, who collected and wrote many of the original columns, and advertising coordinator Julie Corcoran, who has been a key player in organizing the annual Boatyard Dog Trials. Thank you also to the kind people at Down East Books, especially Michael Steere, for their patience. Most of all, thanks to all the dogs, and other animals, who add so much joy to our lives and zest to our magazine, and to their owners for sharing all their wonderful stories. Contacting folks whose pets had been featured in the magazine to let them know about the book was a lot of fun. I was deluged with more photos and stories. One owner sent me a painting he had done of his dog sailing with him. I even received an e-mail from a dog—at least that's what it said. Clearly we love our pets, they love us, and it shows.

—*Maine Boats, Homes & Harbors* Editor Polly Saltonstall

Photo by BIlly Black